Gorseinon College

Learning Resource Centre

Belgrave Road: Gorseinon: Swansea: SA4 6RD Tel: (01792) 890731 This book is **YOUR RESPONSIBILITY** and is due for return/renewal on or before the last date shown.

CLASS NO. 751 4	S GAI ACC. NO.
-3 FEB 2004 13 OCT 2004	
1 8 LER 5001 2 SEB 5002	
	DØ532916

RETURN OR RENEW - DON'T PAY FINES

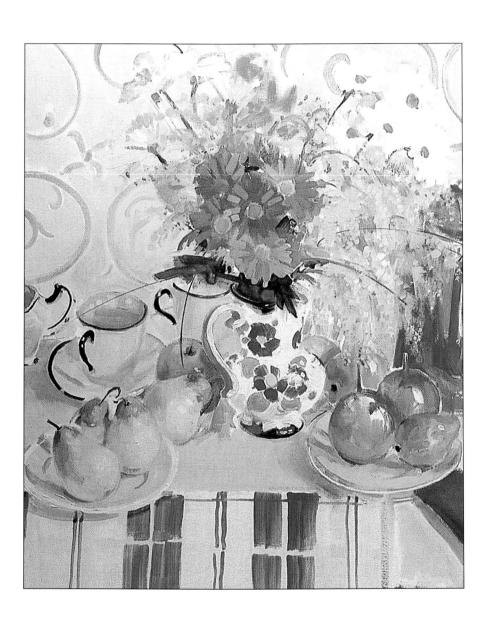

OIL PAINTING COURSE

A Step-by-Step Guide

ANGELA GAIR

ABBEYDALE PRESS

First published in 2002 by Abbeydale Press, an imprint of Bookmart Limited Registered Number 2372865 Desford Road, Enderby Leicester LE9 5AD

© 2002 Bookmart Limited

All rights reserved. No part of this publication may be reproduced, stored in a retrieval system, or transmitted in any way or by any means, electronic, mechanical, photocopying, recording or otherwise without the prior permission of the copyright holder.

Originally published by Bookmart Ltd as part of The Drawing and Painting Course in 1996 and as part of The Artist's Handbook in 1998.

ISBN 1-86147-093-2

Printed in Singapore

Oil Painting

Introduction	9
Materials and Equipment	10
Painting Alla Prima	16
Spring Flowers	17
Toned Grounds	22
Venice, Evening	24
Mixing Greens	30
A Country Scene	32
Blending	38
Still Life in Blue and White	40
Painting Trees	46
Autumn Trees	48
Underpainting	52
The Boudoir	53
Developing the Painting	60
Terrace in Tuscany	62
Impasto	66
Garden in Spring	68
Knife Painting	74
Chania at Night	75
Colour Harmony	80
Marmalade Cat	82
Painting Skies	88
Sky Over Suffolk	90
Indev	94

AN INTRODUCTION TO

Oil Painting

PROJECT 1

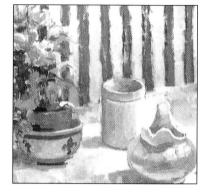

PROJECT 4

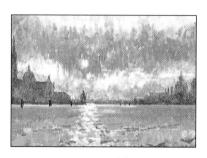

PROJECT 2

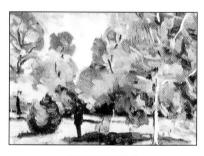

PROJECT 5

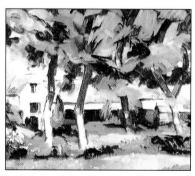

PROJECT 3

PROJECT 6

PROJECT 7

PROJECT 9

PROJECT 8

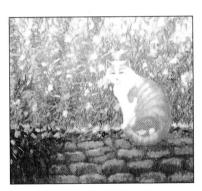

PROJECT 10

PROJECT 11

Materials and Equipment

Materials for oil painting can be expensive, so it is advisable to start out with the basic essentials and add extra colours, brushes and so on as you gain more experience.

PAINTS

Oil paints are sold in tubes and are available in two different grades: artists' and students'. Artists' colours are of better quality and this is reflected in the price. They are made from the finest pigments ground with a minimum of oil so their consistency is stiff, and the colours retain their brilliance well.

Students' colours are labelled with a trade name such as 'Georgian' (Daler-Rowney) or 'Winton' (Winsor & Newton). These paints cost less because they contain less pure pigment and more fillers and extenders; they cannot provide the same intensity of colour as the artists' range. They are, however, fine for practising with. Some artists even combine the two types, using artists' paints for the pure, intense colours and students' paints for the earth colours, which are often just as good as in the artists' range.

Artist-quality paints vary in price according to the initial cost of the pigment. They are usually classified according to a 'series', typically from 1 (the cheapest) to 7 (the most costly). Student-quality colours are sold at a uniform price across the range.

Right Some of the most popular mediums and diluents available for altering the consistency of oil paint. From left to right: dammar varnish, alkyd medium, impasto medium, purified linseed oil, low-odour thinners, white spirit, distilled turpentine. At the bottom right of the picture is a double dipper, which clips on to the palette and holds oil and turpentine separately so you can dip into them as you paint.

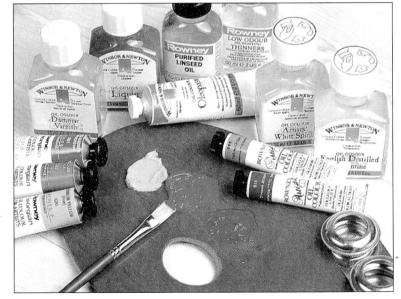

MEDIUMS AND DILUENTS

Oil paint can be used thickly, direct from the tube, but more often it needs to be diluted to make it easier to apply to the support. Paint may be thinned to the required consistency with a diluent such as turpentine or white spirit, or with a combination of a diluent and an oil or varnish – known as a medium.

Diluents

Used on its own, a diluent produces a matt finish and considerably accelerates the drying time of the paint. Always use double-distilled or rectified turpentine for painting purposes – ordinary household turpentine contains too many impurities and is not suitable.

If turpentine gives you a headache or irritates your skin, white spirit is a suitable alternative. It is also cheaper, has less odour, and stores without deteriorating. You can also obtain special low-odour thinners from art suppliers.

Mediums

There are various oils and resins that can be mixed with a diluent to add texture and body to your paint. The most commonly used painting medium is a mixture of linseed oil and turpentine, usually in a ratio of 60 per cent oil to 40 per cent turpentine. Linseed oil is used

SAFETY PRECAUTIONS

Even small quantities of solvents and thinners can be hazardous if not used with care, because their fumes are rapidly absorbed through the lungs. When using solvents, always work in a well ventilated room and avoid inhalation. Do not eat, drink or smoke while working. because it dries to a glossy finish that is resistant to cracking. However, be sure to buy either purified or cold-pressed linseed oil; boiled linseed oil – the sort that is sold in DIY and hardware shops – contains impurities that cause rapid yellowing. If you want a thicker mixture that dries more quickly, you can add a little dammar varnish to the turpentine and linseed oil.

Special ready-mixed painting mediums are available from art suppliers, designed variously to improve the flow of the paint, thicken it for impasto work, speed its drying rate, and produce either a matt or a gloss finish.

BRUSHES

Oil-painting brushes come in a wide range of sizes and shapes. Each makes a different kind

Below Here is a small selection of the vast range of oil-painting brushes available. A bristle brushes: fan, filbert, short flat, long flat. B synthetic brushes: round, flat, filbert. C mahl stick. D household decorator's brush – useful for applying primer to the support.

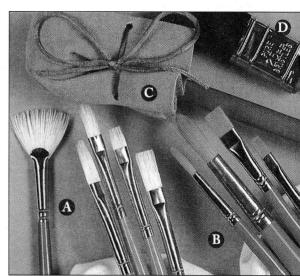

of mark, but some are more versatile than others. Through experiment you will find which ones are best suited to your own painting style.

Bristle brushes

Stiff and hard-wearing, bristle brushes are good for moving the paint around on the surface and for applying thick dabs of colour. The best quality ones are made of stiff, white hog bristles with split ends that hold a lot of paint.

Sable brushes

Sable brushes are soft and springy, similar to those used in watercolour painting, but with longer handles. They are useful for painting fine details in the final layers of a painting and for applying thinly diluted colour. Sable brushes are expensive, however, and for oil painting some artists find synthetic brushes quite adequate.

Synthetic brushes

Synthetic brushes are an economical alternative to natural-hair brushes, and their quality has improved considerably in recent years. Synthetic brushes are hard-wearing and easily cleaned, but the cheaper ones lose their shape quickly.

Brush shapes

Rounds have long, thin bristles that curve inwards at the ends. This is the most versatile brush shape as it covers large areas quickly and is also good for sketching in outlines.

Flats have square ends and long bristles that hold a lot of paint. They are ideal for applying thick, bold colour and are useful for blending. Brights are the same shape as flats, but with shorter, stiffer bristles that make strongly textured strokes. The stiff bristles are useful for applying thick, heavy paint to produce impasto effects.

Filberts are similar to flats, except that the

bristles curve inwards at the end. Filberts are the most versatile brushes as they produce a wide range of marks.

Fan blenders are available in hog bristle, sable and synthetic fibre, and are used for blending colours together where a very smooth, highly finished effect is required.

Decorators' brushes are cheap, hard-wearing and useful for applying primer to the support prior to painting.

Brush sizes

Each type of brush comes in a range of sizes, from 00 (the smallest) to around 16 (the largest). Brush sizes are not standardized and can vary widely between brands. The brush size you choose will depend on the scale and style of your paintings. In general, it is better to start with medium to large brushes as they cover large areas quickly but can also be employed for small touches. Using bigger brushes also encourages a more painterly, generous approach.

Brush care

Good brushes are expensive, but if they are properly looked after they can last for several years. Clean your brushes at the end of every painting day, and never leave a brush soaking with the bristles touching the bottom of the container. First, remove the excess paint on a piece of newspaper, then rinse in white spirit and wipe on a rag. Wash under warm running water, soaping the bristles with a bar of household soap. Rub the soapy bristles in the palm of your hand so that the paint which has collected around the base of the ferrule is loosened. Rinse in warm water, shake dry, then smooth the bristles into shape. Leave the brushes to dry, bristle end up, in a jar. Always make sure brushes are dry before storing them in a closed container, or they may develop mildew.

PALETTES

Palettes for oil painting come in a variety of shapes, sizes and materials, designed to suit the artist's individual requirements. The best-quality palettes are made of mahogany ply, but fibreboard and melamine-faced palettes are perfectly adequate. Use as large a palette as you can, to allow your colours to be well spaced around the edge with plenty of room in the centre for mixing them together.

Thumbhole palettes

Thumbhole palettes come in a range of sizes and are designed to be held in the hand while painting at the easel. They have a thumbhole and indentation for the fingers, and the palette is supported on the forearm. There are three main shapes available: oblong, oval and the traditional kidney-shaped palette.

Preparing wooden palettes

Before they are used for the first time, wooden palettes should be treated by rubbing with linseed oil. This seals the wood and prevents it from sucking oil from the paint, causing it to dry out too quickly on the palette. It also makes the surface easier to clean after use. Rub a generous coating of the oil into both sides of the palette and leave it for several days until it has hardened and fully penetrated the grain.

Disposable palettes

Made of oil-proof paper, disposable palettes are useful for outdoor work and for those artists who hate the chore of cleaning up. They are sold in pads with tear-off sheets; some have a thumbhole.

Improvised palettes

Many artists prefer to use a 'home-made' palette which can be rested on a nearby surface. As well as saving you money, it allows you to

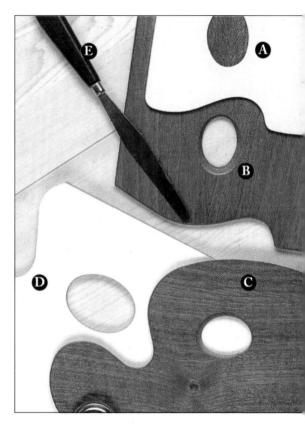

Above Palettes for oil painting. A oblong melamine. B oblong mahogany ply. C kidney-shaped studio palette in mahogany ply. D pad of tear-off disposable palettes. A palette knife, E, is used for mixing paints together on the palette.

choose any size, shape and material you like. Any smooth, non-porous material is suitable, such as a sheet of white formica, a glass slab with white or neutral-coloured paper underneath, or a sheet of hardboard sealed with a coat of paint. Old cups, jars and tins are perfectly adequate for mixing thin washes, and can be covered with plastic film between sessions to prevent the paint drying out.

SUPPORTS

The support is the surface on which you paint – whether canvas, board or paper. A support for oil painting must be prepared with glue size and/or primer to prevent it absorbing the oil in the paint; if too much oil is absorbed, the paint becomes underbound and may eventually crack.

Canvas

The most popular surface for oil painting is canvas, which has a unique responsiveness to the brush and plenty of tooth to hold the paint. Canvas is available in various weights and in fine, medium and coarse-grained textures. You can buy it either glued onto stiff board, ready-stretched and primed on a wooden stretcher frame, or in lengths from a roll. Prepared canvases are expensive and it is much cheaper to buy lengths of unprimed canvas and stretch and prime your own.

The weight of canvas is measured in ounces per square yard. The higher the number, the greater the density of threads and therefore the better the quality. The two main types of canvas available are linen and cotton.

Linen is considered the best canvas. It has a fine, even grain that is free of knots and a pleasure to paint on. Although expensive, it is very durable.

Cotton Good-quality cotton canvas, such as cotton duck, comes in 12oz and 15oz grades. It stretches well and is the best alternative to linen – at about half the price. Lighter-weight

Below Oil paint can be applied to a wide range of supports. A stretched and primed canvas. B plywood. C hardboard. D oil sketching paper. E linen canvas. F cotton canvas (both of these need to be stretched and primed). G cardboard. H prepared canvas panel.

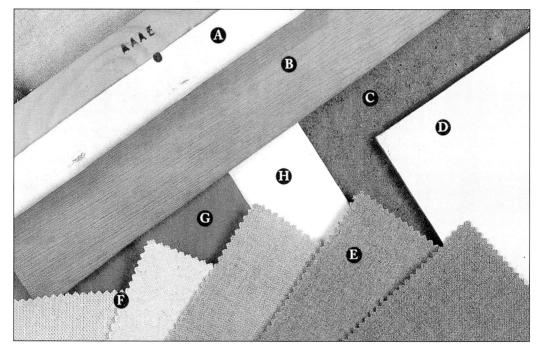

canvases are recommended for practice work only.

Boards and papers

Prepared canvas boards are relatively inexpensive and are ideal when trying out oils for the first time. However, the cheaper ones have a rather mechanical texture and a slippery surface. Hardboard, which you can buy from builders' suppliers, is an excellent yet inexpensive support for oils. Most artists use the smooth side, as the rough side has a very insistent, mechanical texture.

Plywood, chipboard, MDF (medium-density fibreboard) are also suitable for oil painting. Prepare the board with primer if you like a white surface, or, if you prefer to work on a neutral mid-toned surface, simply apply a coat of glue size or PVA to the support.

Oil sketching paper is specially prepared for oil painting and is textured to resemble canvas weave. Available in pads with tear-off sheets, it is handy for outdoor sketches and practice work.

PAINTING ACCESSORIES

Painting in oils can be a messy business, so the most essential accessories you will need are large jars or tins to hold solvents for cleaning brushes, and a good supply of cotton rags and newspaper! The following items are not essential, but some, such as palette knives, you will certainly find useful.

Painting knives have flexible blades and cranked handles, and can be used instead of a brush to apply thick paint directly to the support.

Palette knives have a long, straight, flexible blade with a rounded tip. They are used for mixing paint on the palette and for scraping paint off the palette at the end of a working session.

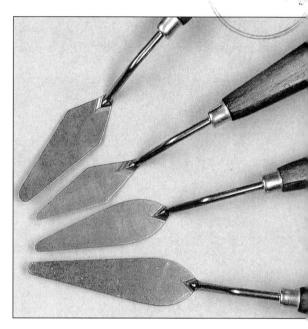

Above Painting knives come in a range of shapes and sizes. They are not an essential item unless you intend to experiment with knife-painting techniques.

Dippers are small open cups that clip onto the edge of your palette to hold mediums and thinners during painting. These are not essential – you can just as easily keep small jars of painting medium on a nearby surface.

Mahl stick This is useful for steadying your hand when painting small details or fine lines. It consists of a long handle made of bamboo, wood or metal, with a rubber or chamois cushion at one end. Hold the mahl stick so that it crosses the painting diagonally, the padded end resting lightly on a dry section of the work, or on the edge of the canvas. You can then rest your painting arm on the stick to steady yourself as you paint. You can make your own mahl stick from a length of dowelling or garden cane with a bundle of rags tied to one end.

Painting Alla Prima

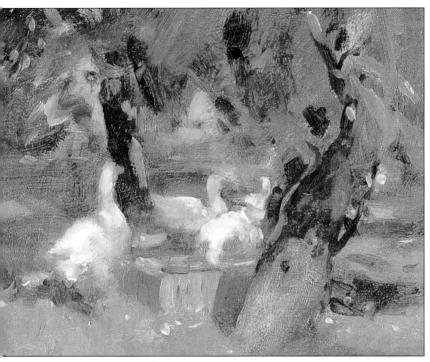

Trevor Chamberlain ERIC'S GEESE
The artist had to work quickly to capture this delightful scene before the light changed and the geese wandered off.
By using thinned paint and rapid, wet-in-wet brushstrokes, and by working on a small scale, he was able to complete the picture in about two hours.

Alla prima is an Italian expression meaning 'at the first'. It describes a technique in which a painting is completed rapidly in a single session, as opposed to the 'traditional' method of working up the image layer by layer over an extended period.

The alla prima method is often used by artists when painting outdoors directly from the subject, where speed is essential in order to capture the fleeting effects of light and movement in the landscape. In alla prima painting there is usually little or no initial underpainting, although artists sometimes make a rapid underdrawing in charcoal or thinned paint to act as a compositional guide. Each patch of

colour is laid down more or less as it will appear in the final painting, or worked wet-into-wet with adjacent colours; the main idea is to capture the essence of the subject in an intuitive way using vigorous, expressive brush strokes and minimal colour mixing.

Alla prima painting requires a confident approach. It is, of course, possible to scrape away and rework unsuccessful areas of a painting, but the danger is that some of the freshness and spontaneity will be lost. It is therefore important to start out with a clear idea of what you want to convey in your painting. Make a positive statement, and don't be tempted to include any unnecessary, cluttered detail.

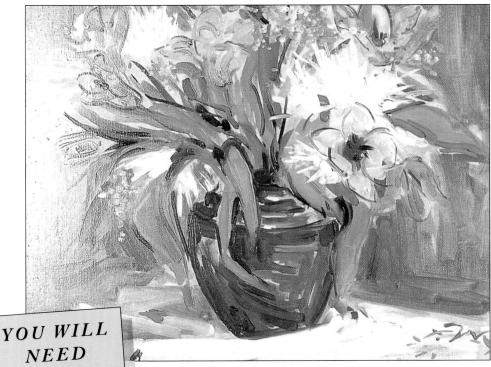

Sheet of primed canvas or board, 18 x 14in (45.7 x 35.6cm)

No. 2 round bristle brush

No. 2 filbert bristle brush

No. 8 filbert bristle brush

- No. 10 flat bristle
 brush
- ✓ Turpentine
- ✓ Linseed oil
- Clean rag

Spring Flowers

This painting was completed quickly, using a limited palette

OIL PAINTS IN THE FOLLOWING COLOURS

- Naples yellow
- Chrome yellow
- Permanent rose
- Cadmium red
- Burnt siennaCadmium green
- Yellow ochre
- Alizarin crimson
- Olive green
- French ultramarine
- Cobalt blue
- Cobalt violet
- Titanium white

of colours. Bold, expressive brushwork gives rhythm to the composition, leading the eye around it from one area to another.

OIL PAINTING

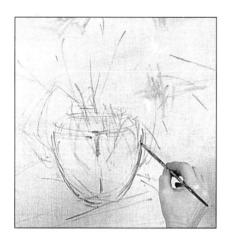

Prepare the canvas by tinting it the day before you start painting, so that it has time to dry. Mix yellow ochre, French ultramarine and a little cadmium green, then dilute with lots of turpentine to make a very thin wash of pale grey-green. Rub the colour over the entire canvas area using a rag dampened with a little turpentine. Using a no. 2 filbert brush, lightly sketch in the main outlines of the composition with thin paint. Use French ultramarine for the vase, cobalt violet and titanium white for the tulips and cadmium green for the stalks. Hold your brush lightly, well back from the bristles, and draw with loose, fluid lines, feeling your way around the forms.

Establish the lightest tones in the composition – the white daisies and the highlights on the folds of the white tablecloth – using the 'rub-out' technique: fold a clean rag over your finger, dip it in turpentine, and remove some of the base colour, down to the bare canvas, as shown.

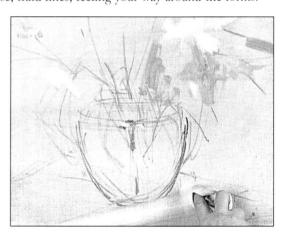

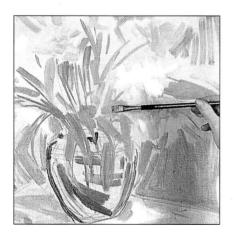

Now start to build up the composition as a whole, working on related areas simultaneously with small touches of thin paint. With a no. 10 flat brush, mix burnt sienna, yellow ochre and a little cadmium red to make a warm brown and loosely block in the background with broad strokes. Mix French ultramarine, alizarin crimson and white to create the shadows and folds in the tablecloth. Add strokes of ultramarine to the vase, following its curved form with your brush strokes. Paint the tulip leaves with cadmium green. For the darker leaves, add a touch of ultramarine and white to create a green with a hint of grey.

With a no. 8 filbert brush, work on the forms of the flowers. Use pure white, and white warmed with a little Naples yellow, for the daisies. Plot the light and dark tones of the tulips using various mixes of cobalt violet, cobalt blue, permanent rose and white. Apply the colours rapidly so you don't get bogged down in detail – concentrate instead on capturing the gestures of the petals.

Helpful Hint

IT'S IMPORTANT TO KEEP YOUR
COLOURS FRESH AND UNSULLIED, SO
RINSE YOUR BRUSHES FREQUENTLY
IN A JAR OF WHITE SPIRIT.

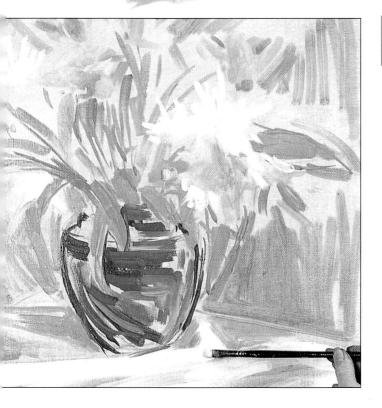

Now your painting is taking shape. From here on, mix your paint with turpentine and linseed oil to give it more body. Build up the reflections in the vase with French ultramarine, darkened with a touch of cobalt violet for the deepest tones, and cobalt blue and white for the highlights. Work on the folds in the tablecloth, deepening the shadows with a mix of burnt sienna and cobalt violet and adding white to the raised folds. Keep your brush moving and work on all the areas of the canvas.

Continue working on the vase with the same colours used in step 4. Add hints of cobalt violet to echo the colour of the tulips, and touches of pure white for the bright highlights. Let your brushstrokes describe the vase's rounded shape. Add tone and form to the leaves with a mixture of olive green and cadmium green, adding a little white for the highlights.

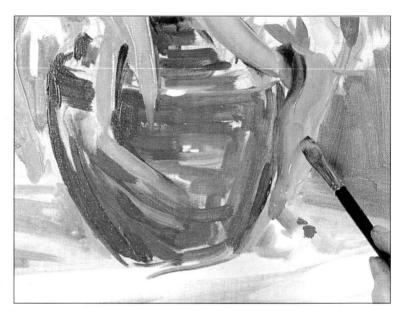

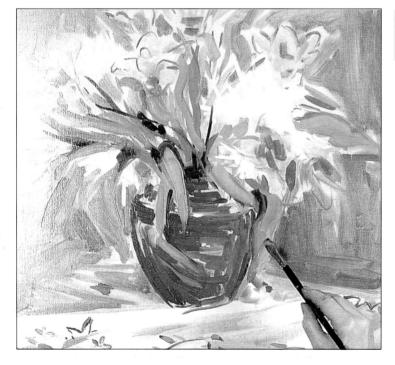

With a no. 2 round brush and cobalt violet, define the shapes of the tulips. With a no. 10 flat brush, fill in the background behind and between the flowers with a mix of burnt sienna, yellow ochre, chrome yellow and cadmium red. Suggest the embroidered flowers on the tablecloth using French ultramarine, cobalt blue and white for the petals, chrome vellow for the centres, and cobalt green darkened with cobalt blue for the stalks and leaves.

PAINTING ALLA PRIMA

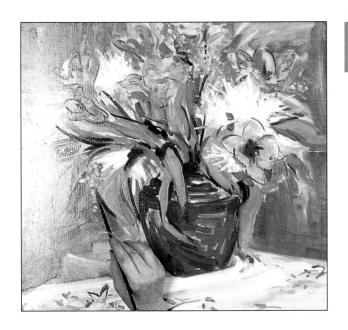

Add more white, mixed with a touch of cobalt blue, to the folds at the base of the vase. Using a no. 2 round brush, pick out the spiked petals of the daisies with pure white. Continue working on the tulips with mixtures of cobalt violet, cobalt blue, permanent rose and white, and touch in the stamens with pure cobalt violet. Let your brushstrokes follow the curved forms of the petals and allow the colours to mix wet-intowet on the canvas. Mix cobalt violet and white and dot in the tiny statice flowers.

Stand back from the picture to see if there are any final adjustments that need to be made. Don't be tempted to add any unnecessary detail, however, otherwise you will lose the freshness and immediacy of your alla prima painting.

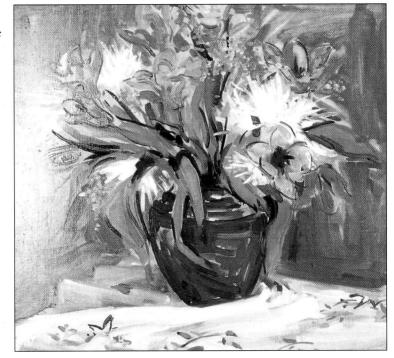

Toned Grounds

James Horton

BOYS BATHING AFTER A STORM In this painting the artist has toned the canvas with a diluted earth colour. The toned ground breaks through the overlaid strokes, its warm colour providing a lively contrast with the cool greys of the sea and sky.

Once a canvas or board has been primed it can be given a wash of colour using thinned paint applied with a brush or a rag, and this is called a toned ground.

Toning the ground serves two purposes. First, it softens the stark white of the primed canvas or board, which can make it difficult to assess colours and tones accurately. A colour like red, for instance, may look quite dark when applied to a white canvas; but as the painting

progresses that same red will be surrounded by other colours, and suddenly it looks much lighter. A neutral, mid-toned ground provides a more sympathetic surface on which to paint, and you can work out to the light and dark tones with equal ease.

Second, if patches of the coloured ground are allowed to show through the overpainting in places, they become an integral element of the painting and act as a harmonizing influence by tying the separate elements together.

Choosing the ground colour

The colour chosen for a toned ground will depend on the subject you are painting, but it is normally a neutral tone somewhere between the lightest and the darkest colours in the painting. The colour should be subtle and unobtrusive so that it does not overwhelm the colours in the

overpainting. Diluted earth colours such as Venetian red, raw sienna or burnt umber work very well, as do soft greys and greens. Some artists like a ground that harmonizes with the dominant colour of the subject; others prefer a ground which provides a quiet contrast. For instance, a warm red-brown enhances the greens in a landscape, while a soft ochre adds brilliance to the blues in a skyscape.

Applying the ground

Dilute the paint thinly with turpentine or white spirit and apply it with a large brush (a decorator's brush is useful). After a few minutes, rub with a clean rag, leaving a transparent stain of colour which is ready to paint on the following day. Alternatively, some artists prefer to apply the colour vigorously, leaving the brushmarks showing.

Always make sure the toned ground is completely dry before you paint over it. An oil ground usually takes around 24 hours to dry thoroughly, but if time is short you can use acrylic paint instead. Acrylic is an alkyd-based paint which is water soluble. It dries in minutes, allowing you to overpaint in oils straight away (though you should never apply acrylics over oils as this causes the picture surface to crack. This is because oils are more flexible and slow-drying than acrylics).

The other great advantage is that acrylic paint acts as both a sealing agent and a primer, so you don't need to size and prime the canvas as you would for oils (never apply acrylics on a ground which has been sized and primed for oils, however, as this may lead to eventual cracking of the paint film).

James Horton

GRANTCHESTER, CAMBRIDGE

Here the toned ground has been chosen to harmonize, rather than contrast with, the colours in the painting. Although much of the ground is covered up, it has an important role to play, modifying the greens in the landscape and unifying the picture.

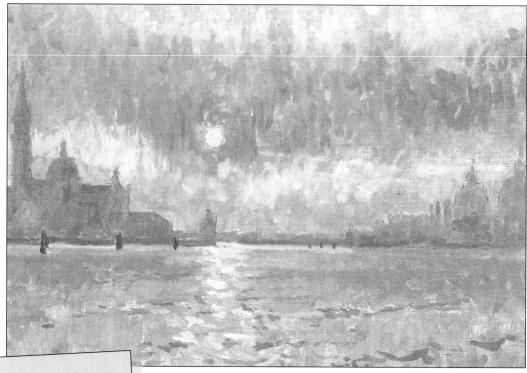

YOU WILL NEED

- Canvas board, 14 x 9½in (35.6 x 24.2cm)
- No. 2 round sable brush
- No. 5 round bristle brush
- 1½in (38mm) decorating brush
- ✓ Turpentine
- V Linseed oil
- V Dammar varnish

Venice, Evening

A carefully chosen toned ground can act as a mid tone and provide a link between disparate areas of colour. In this lovely painting, small patches of the umber ground remain exposed throughout the picture, their warm colour helping to unify the

OIL PAINTS IN THE FOLLOWING COLOURS

- Raw umber
- Burnt sienna
- French ultramarine
- Cerulean
- Alizarin crimson
- Cadmium red
- Cadmium orange
- Lemon yellowTitanium white
- Ivory Black

composition and enhancing the impression of the shimmering light of Venice at sunset.

Cover the whole surface of the canvas board with a transparent wash of raw umber, diluted to a thin consistency with turpentine. Use a $1^{1/2}$ in (38mm) decorating brush for this. The aim is to knock back the stark whiteness of the primed board and establish a warm mid tone against which you can judge the lighter and darker tones. Leave to dry overnight. Dilute raw umber and burnt sienna with turpentine and sketch in the main outlines of the scene. including the orb of the sun, with a no. 2 round sable brush

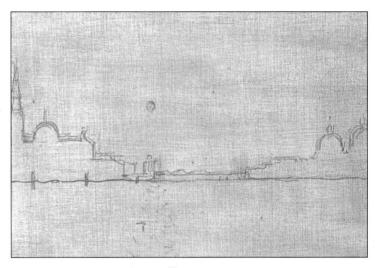

Helpful Hint
WHEN PAINTING LANDSCAPES,
AVOID PLACING THE
HORIZON LINE IN THE
CENTRE OF THE CANVAS AS
THIS EFFECTIVELY CUTS THE
PICTURE IN HALF.

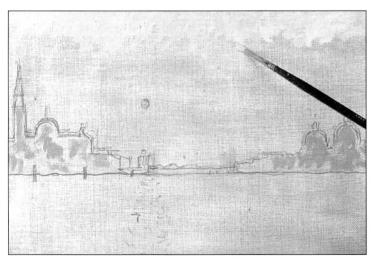

From here on, mix your colours with a little medium, consisting of equal amounts of linseed oil and dammar varnish and twice the amount of turpentine. Mix a warm grey from raw umber. French ultramarine and alizarin crimson and loosely touch in the buildings in the distance with a no. 5 round bristle brush. Then mix a vibrant, turquoise grey with ultramarine, white and a little lemon yellow and paint the upper part of the sky with random brushstrokes. letting the ground show through.

OIL PAINTING

With the same brush, continue painting the sky, starting beneath the first band of colour with a combination of ultramarine, alizarin crimson, titanium white and a tiny spot of ivory black. As you work down towards the horizon, add more alizarin and a little more white to the mix so that the sky gradually takes on a warm, violet hue. Again, apply the colours with loosely spaced marks, leaving plenty of the ground colour showing through.

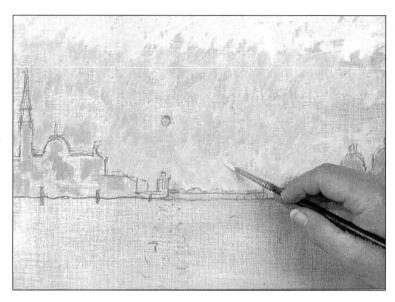

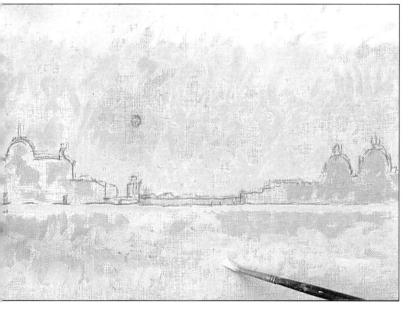

Start to work up the greenish tones in the water, leaving a 'pathway' for the sun's reflection. The basic colours are ultramarine, lemon vellow, cerulean and white - mix these in different combinations to give a range of greenish greys. For example, add more blue for the darker, cooler greens and more yellow or white for the lighter, warmer hues. Suggest light shining on the distant water with a band of pale green.

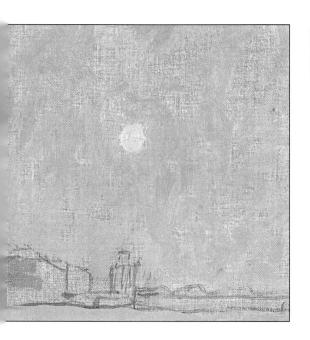

Mix lemon yellow, cadmium orange and white and paint the brilliant orb of the sun. Use fairly thick paint so that it catches the light. Then mix ultramarine, alizarin and white and use this to create a cool 'halo' of blue-grey around the sun, using loose strokes that follow a circular shape. This is an example of how one colour can be influenced by neighbouring colours; the yellow sun appears more brilliant in contrast with the darker tone of grey surrounding it.

Paint the group of buildings on the left of the picture with soft blueviolet greys mixed from various amounts of ultramarine, alizarin, black and white (make use of the greys already mixed on your palette). Instead of 'filling in' with a flat layer of paint, apply small strokes and dabs of subtly modulated colour. Allow small patches of the toned ground to show through the strokes; this gives a soft effect that suggests hazy evening light gently enveloping the scene.

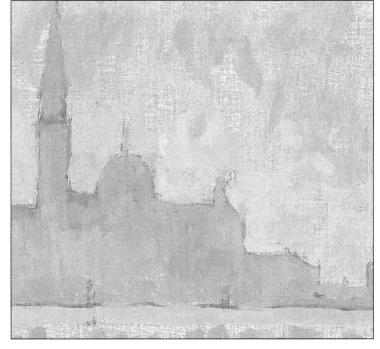

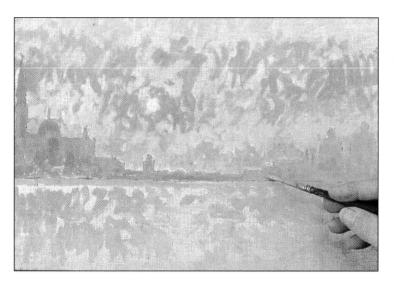

Suggest the soft rosy glow in the sky near the horizon with a mixture of cadmium red, lemon yellow and lots of white, applied with loose strokes. Now fill in the rest of the buildings, which lie behind those on the left. Use the same mix as in step 6, adding more white to lighten the tone and push the buildings back in space.

Mix lemon yellow, cadmium orange and white and paint the sun's broken reflection on the water. Use a no. 2 round sable brush to make rhythmic strokes and ticks that suggest the gentle lapping of the water. To enhance the effect of space and perspective, make these strokes smaller and more closely spaced in the distance, as well as lighter in tone.

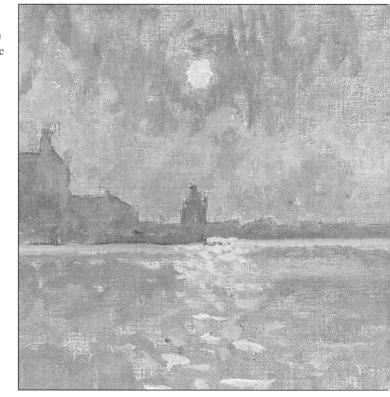

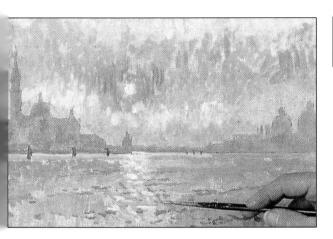

Mix ultramarine, alizarin and a little black to paint the tops of the wooden poles sticking out of the water, just visible in the distance. Then mix ultramarine and lemon yellow, warmed with cadmium orange, and touch in the small dark waves.

Look for the tonal balances of colour and make sure nothing jumps out at you – the effect should be one of hazy evening light. Any sharp divisions of colour can be softened and blended by gently hatching over them with a no. 2 round sable brush, to produce atmospheric blends and veils of colour.

Helpful Hint
WHITE IS USED A LOT IN
OIL-PAINTING MIXTURES, SO
IT IS MORE ECONOMICAL TO
BUY A LARGE TUBE OF IT.

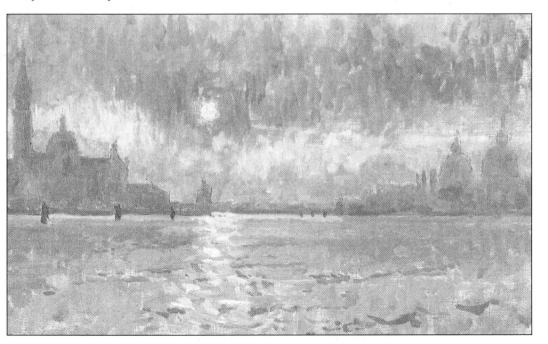

Mixing Greens

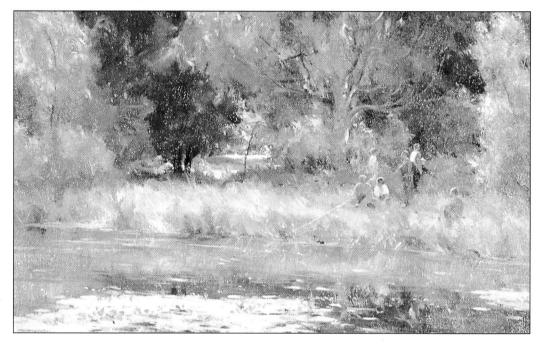

David Curtis

FISHING BY THE LAKE

A rich variety of greens is woven throughout this painting. Note how a sense of depth is created by using warm greens in the foreground and cooler greens in the distance.

Green is often the dominant colour in landscapes, but that green can vary enormously from almost blue to near yellow.

Before you start to mix paint, it is worthwhile to go out and observe the landscape, comparing the different greens to each other. On a bright day, for instance, sunlit areas of grass and foliage are a warm, yellowish green, while those greens in shadow appear cooler and bluer. And if you look towards the horizon, you will see that the greens of trees, fields and hills appear progressively cooler, bluer and paler in tone as they recede into the distance.

Where many inexperienced painters go wrong is in painting an entire landscape using ready-mixed greens straight from the tube, and simply adding white or black to make them lighter or darker. Because there aren't enough contrasts of light and dark tone and warm and cool colour, the result is a flat, monotonous painting with no feeling of light.

If you want to paint realistic landscapes, it is worth learning how to mix more lively greens, and there are two ways in which you can do this: using tube greens modified with other colours, and mixing your own greens from blues and yellows.

Modifying tube greens

There are several greens available ready-mixed in tubes, but most of them are too intense, not like the soft greens of nature. However, tube greens are excellent when modified by the addition of other colours on your palette. For example, viridian is an intense, cold green that looks unnatural in its pure state. But by adding red, yellow or orange to it, it is possible to create a whole range of life-like greens.

Mixing blues and yellows

Blues and yellows mixed together give an even wider range of rich and subtle greens that can be varied from light to dark, bright to muted and warm to cool. Such greens can be further adjusted by adding a third colour, such as a touch of red if the green is too bright and you want to tone it down a little.

Discover for yourself the value of mixing your own greens. Take three blues – cerulean, cobalt and ultramarine – and three yellows – lemon, cadmium and ochre. Add each of the yellows to each of the blues, and you instantly have nine different greens, ranging from bright, leafy hues to warm, rich tones. Start with a 50:50 mix, then see what happens when you alter the proportions of each colour in turn: adding more blue creates darker, cooler greens, while more yellow creates brighter, warmer greens. You can extend the possibilities even further by experimenting with adding touches of earth colours such as raw sienna or raw umber to make even richer greens.

Warm and cool greens

Colours are classed as being either 'warm' or 'cool' in temperature, and in general blue is regarded as cool, and yellow as warm.

However, within this broad definition, some blues are warmer or cooler than others, and the same goes for yellows. French ultramarine contains a hint of red, so is warmer than cerulean; lemon yellow has a green cast, so is cooler than cadmium yellow.

Bear this in mind when mixing greens for your landscapes; if you want a cool green for painting shadowy foliage, it makes sense to choose a cool blue such as Winsor blue and a cool yellow such as lemon yellow. If you want a warm, rich green for sunlit foliage, try a blend of ultramarine and cadmium yellow. When mixing colours, bear in mind that some colours are strong and others weak. A little cadmium yellow, for instance, goes a long way, so add it in small amounts.

The colour swatches below demonstrate just some of the colour combinations that will give you a wide range of lively and expressive greens.

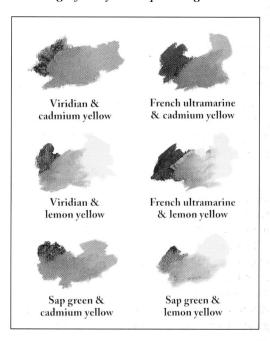

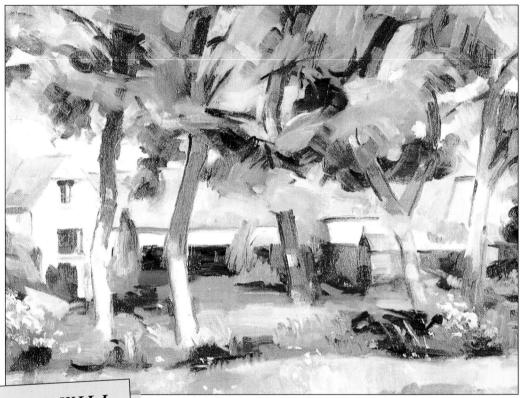

YOU WILL NEED

- Sheet of canvas board, 20 x 16in (50.8 x 40.6cm)
- Nos. 2, 5 and 10 flat bristle brush
- ✓ No. 4 filbert bristle brush
- ✓ Distilled turpentine
- ✓ Purified linseed oil
- ✓ Charcoal

A Country Scene

In this lively painting the artist has succeeded in mixing a wide range of foliage greens, from cool blue shades to vibrant yellow hues. He used a limited palette of colours, mixing greens from

OIL PAINTS IN THE FOLLOWING COLOURS

- Lemon yellow
- Spectrum yellow
- Yellow ochre
- Venetian red
- Cobalt violet
- Chrome oxide green
- Permanent green
- French ultramarine
- Cerulean
- Titanium white

various blues and yellows and modifying tube greens with other colours.

Sketch in the main outlines of the composition with charcoal. Dilute some chrome oxide green with turpentine so it flows easily and, with a no. 4 filbert bristle brush, loosely paint in the main areas, using the charcoal marks as a guide.

Mix a cool green from permanent green, French ultramarine and chrome oxide green, adding a little linseed oil to the turpentine to make the paint more workable. With a no. 10 flat brush, work across the canvas using broad strokes to block in the darkest areas in the pine trees and the cast shadows on the grass. Vary the direction of your brush strokes to convey the direction of growth of the branches.

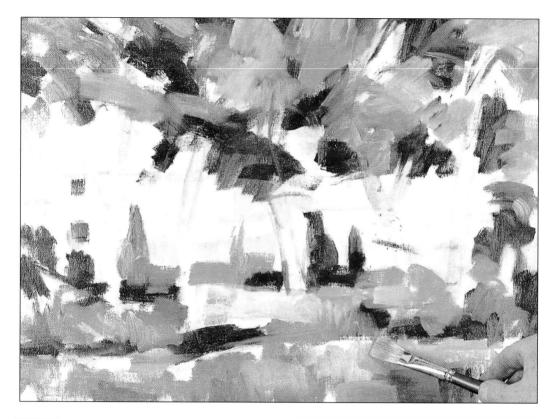

Now bring in some yellow ochre, lemon yellow and spectrum yellow, mixing them with the greens and blues in varying proportions to make a range of warmer, lighter greens for the sunlit foliage and grass. Partially blend the colours on the canvas and vary the proportions of the colours in your mixes, adding more yellows to warm up the sunny greens and more blue to cool down the shadowy greens. Add a little titanium white to the palette to introduce light to the picture, but not too much as it tends to make the colours go dull and chalky.

Mix a pale blue from cerulean and titanium white and paint the sky, cutting in around the foliage. Paint the clouds with white and a hint of cerulean. Use a no. 5 flat brush for the broad areas and a no. 2 for the smaller patches.

With a no. 4 filbert brush. block in the pinks and browns of the buildings in the background with broad strokes. Use a base mixture of Venetian red and titanium white, adding some yellow ochre and spectrum vellow for the warmcoloured roofs and some cobalt violet and cerulean for the slate roof in the middle.

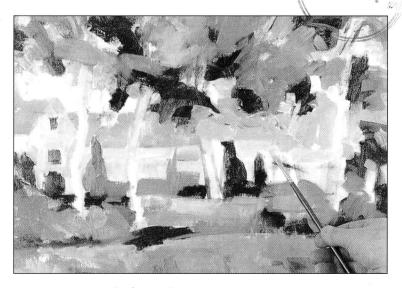

Helpful Hint
TRY TO INTRODUCE TOUCHES OF SIMILAR COLOUR
IN DIFFERENT PARTS OF THE PICTURE. THIS WILL
CREATE A SATISFYING, HARMONIOUS EFFECT.

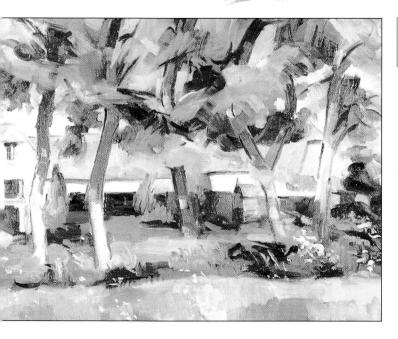

The canopy of foliage casts violet-tinged shadows onto the upper parts of the tree trunks; paint these using mixtures of cobalt violet, ultramarine and a little Venetian red, varying the proportions of the colours to create light and dark tones. Now that you have blocked in most of the base colours, you can begin to work over them to develop contrasts of tone and texture.

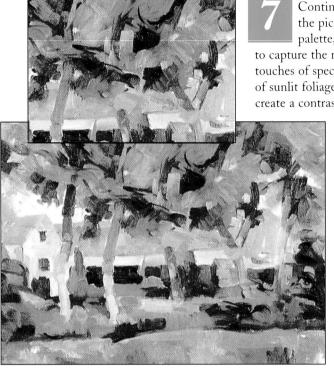

Continue working on the green areas of the picture using all the colours on your palette, including a little violet and blue to capture the really deep tones in the trees. Add touches of spectrum yellow to brighten the patches of sunlit foliage at the outer edges of the trees and create a contrast with the dark tones in the

shadows. In the detail (left) you can see how the artist has partially blended his colours on the canvas. wet-into-wet, and varied the angle of his brush to create lively marks that give a sense of movement to the foliage.

Helpful Hint

GREENS CAN BE LIGHTENED WITH WHITE OR YELLOW AND DARKENED WITH BLACK, BLUE OR RED. WHITE MAKES SOME COLOURS APPEAR CHALKY, AND BLACK CAN HAVE A DEADENING EFFECT.

Go over the buildings with a no. 2 flat brush, putting in outlines and the shadows under the eaves with a mixture of cobalt violet and ultramarine. Darken the shadows on the tree trunks with the same colour; this contrast of dark tone against the lighter tones of the buildings helps to create a sense of space and depth in the picture.

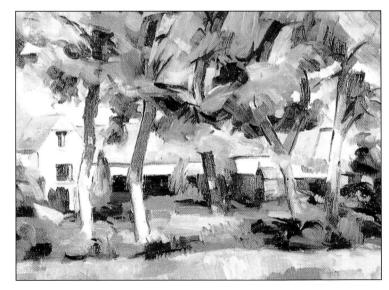

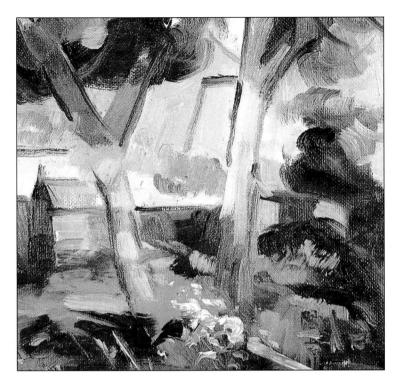

Now start adding the details, suggesting the rose bushes in the foreground with dabs of Venetian red and titanium white. Roll the well-loaded brush over the surface to deposit the paint – this technique is known as scumbling.

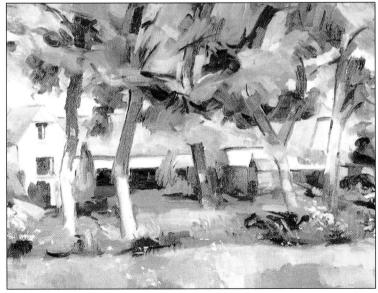

The final picture gives a lively impression of sunlight breaking through the shady pine trees. Notice the variety of greens the artist has used, from cool blue-greens through to vibrant yellow-greens. A refreshing note of contrast is provided by the warm, reddish tones of the buildings in the background.

Blending

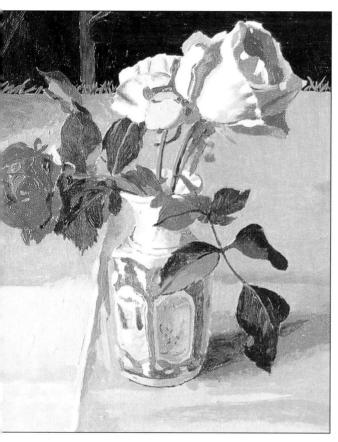

Jeremy Galton
ROSES IN BLUE VASE

Too many sharply focused edges can make delicate subjects look hard and brittle. This floral still life shows how the sensitive handling of tones and edges can suggest form without overstatement. Notice how most of the tones and colours are blended wet-into-wet, with just a few crisp touches here and there to bring the picture into focus.

Blending is a means of achieving soft gradations between adjacent tones or colours by brushing them together where they meet, wet-into-wet. Oil paint lends itself readily to the blending technique because its soft, buttery consistency and slow drying time mean the paint can be freely manipulated on the painting surface.

Subjects

Smooth gradations of colour are used in painting to render specific materials and surface qualities such as soft fabrics, skin tones, flowers, fruits and the reflective surfaces of metal and glass. They are also used to describe certain atmospheric impressions found in the landscape, such as skies and clouds, fog and mist, and reflections in water. In landscapes and seascapes, an impression of space, light and atmosphere can be created by softening the line where sky and horizon meet.

Techniques

The techniques of fusing colour fall between two extremes. On the one hand you can blend the colour with your brush so smoothly and silkily that the brushstrokes are imperceptible even when viewed close-up. At the other extreme it is possible to roughly knit the colours together so that the brushmarks remain visible at close quarters; when viewed at a distance the colours appear to merge together, yet they retain a lively quality because they are only partially blended.

Brushes

Any type of brush can be used for blending, depending on your style of painting. Some artists use stiff-bristled brushes so as to retain the liveliness of the brushstrokes. Others prefer to use softhair brushes to achieve very smooth, perfect gradations. Special brushes called 'fan blenders' – they have long hairs arranged in a fan shape – are specially adapted for smooth blending; work over the edge between two tones or colours using a gentle sweeping motion until a smooth, imperceptible blend is achieved.

David Curtis

HOT AUGUST EVENING, RIVER IDLE Colour, composition and brushwork all contribute to the peaceful atmosphere of this pastoral scene. A harmonious palette of warm colours sets the mood; and the smoothly blended brushstrokes capture the hazy light of a summer evening.

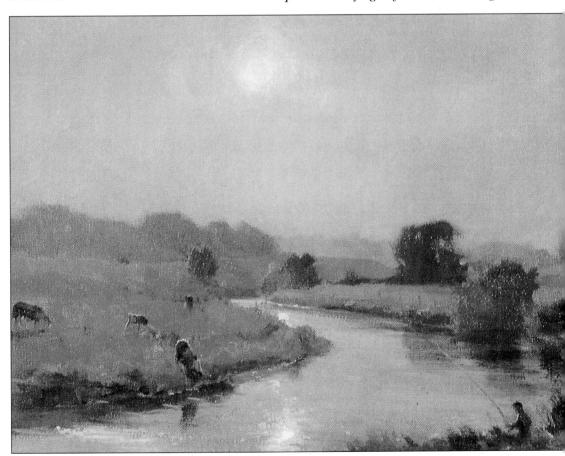

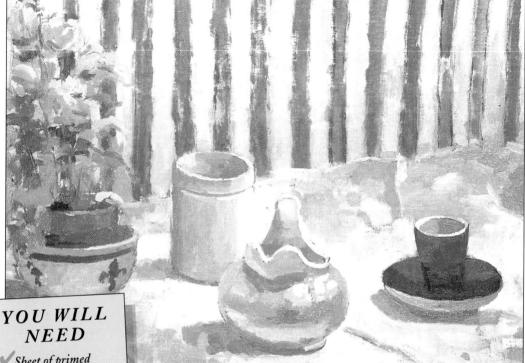

- Sheet of primed canvas or board, 12 x 9in (30.5 x 22.8cm)
- 11/2in (38mm) decorating brush
- No. 5 round bristle brush
- No. 2 round sable brush
- No. 4 round sable brush
- No. 4 filbert bristle brush
- Refined linseed oil
- **V** Distilled turpentine
- Dammar varnish

Still Life in Blue and White

In this painting the artist has blended his colours softly into one another, wet-into-wet, producing gentle gradations of tone and hue that describe

OIL PAINTS IN THE FOLLOWING COLOURS

- French ultramarine
 Burnt sienna
- Cerulean
- Yellow ochre
- Naples vellow
- Veridian
- Raw umber
- Cadmium red Alizarin crimson
- Titanium white
- Ivory Black

the rounded forms of the jugs and bowls and give them solidity and weight.

Start by staining your canvas or board with a thin wash of cadmium red mixed with a little French ultramarine. Use a 1½in (38mm) decorating brush to spread the colour over the surface in wide sweeps. Leave to dry overnight. Then sketch in the main outlines of the composition with a no. 2 round sable brush and burnt sienna, thinned to a watery consistency with turpentine.

Helpful Hint

THE ARTIST MIXED HIS PAINTS WITH EQUAL PROPORTIONS OF LINSEED OIL AND DAMMAR VARNISH, PLUS TWICE THE VOLUME OF TURPENTINE. THE ADDITION OF DAMMAR VARNISH TO THE BASIC TURPS AND OIL MEDIUM GIVES A RICH, ENAMEL-LIKE QUALITY TO THE PAINT.

From this point, mix your colours with an oil medium (see Helpful Hint above) to make the paint more workable. Squeeze some titanium white onto your palette and blend tiny touches of yellow ochre and raw umber into it, just to take the edge off the white. With a no. 5 round bristle brush, roughly block in the white stripes on the wallpaper and start to paint the white cloth, twisting and turning the brush to create lively strokes.

Mix two blues for the blue stripes on the wallpaper: French ultramarine and white for the darker, warmer stripes, and cerulean and white for the cooler, lighter stripes behind the plant. Use fairly dry paint and keep them quite 'sketchy' in feel so that they stay in the background – if they are too clearly defined they will leap forward in the picture plane.

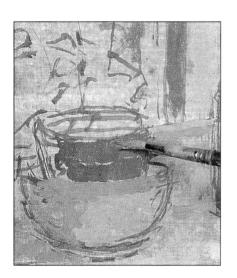

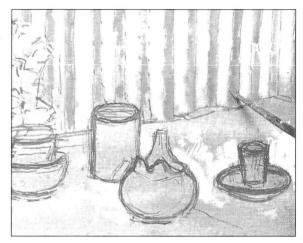

Establish the broad areas of light and shade on the china bowl and block them in, using a mix of French ultramarine, ivory black, alizarin crimson and white for the lighter tone, and a darker mix with yellow ochre added for the dark tone. Do the same for the terracotta plant pot, using various proportions of cadmium red, burnt sienna and white to create the light, dark and mid tones. Block these in quite broadly, making no attempt to blend the colours at this stage.

Rather than committing to one area in detail, move around the picture putting in touches of colour so that you can assess how the various tones and colours are balancing each other. Paint the deep shadows on the jug and jar with yellow ochre and raw umber, then block in the mid tones using the greys mixed in step 4. Add touches of pale mauve, mixed from ultramarine, alizarin, white and a hint of black, where colour is reflected onto the jug and jar from the pink cyclamen flowers. Mix Naples yellow and white for the highlight on the right side of the jar. Use the same colours to establish the soft shadows on the white cloth.

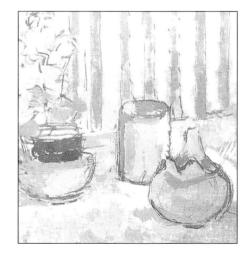

Now paint the blue egg cup and saucer with a mixture of ultramarine and cerulean, darkened with alizarin crimson for the shadow areas.

Helpful Hint

IF YOU FIND IT DIFFICULT
TO ASSESS THE RELATIVE TONES
IN YOUR SUBJECT, TRY LOOKING
AT IT THROUGH HALF-CLOSED
EYES. THIS CUTS OUT MUCH OF
THE DETAIL, ALLOWING YOU TO
SEE THE LIGHTS, DARKS AND
MID TONES MORE CLEARLY.

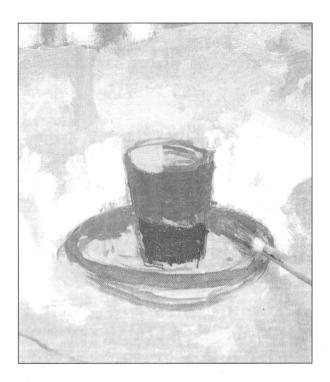

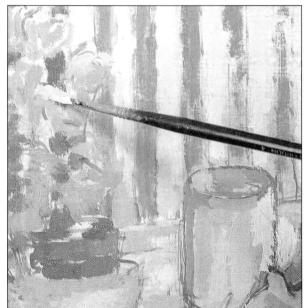

Switch to a no. 4 round sable brush and establish the main forms of the cyclamen plant. For the leaves, make up a series of warm and cool greens mixed from varying amounts of viridian, ultramarine, white, and grey from the palette. Do the same for the flowers, mixing warm and cool pinks from cadmium red (a warm red), alizarin crimson (a cool red) and white.

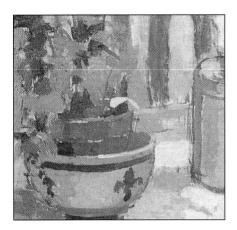

Use the same brush to paint the blue pattern on the china bowl with a mixture of ultramarine and white, darkened with a little alizarin crimson where the pattern turns into shadow.

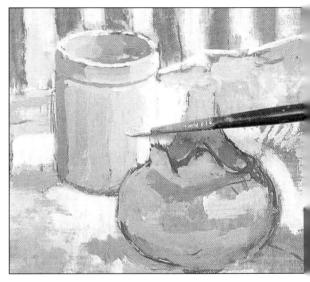

With everything in place and the broad tones and colours established, you can start to define the form and volume of the objects by blending the tones together to create smooth gradations. Working on the jar with the no. 4 round sable brush and the same colours used for the

initial block-in, create a more even progression of tones from light to dark. Apply the colours wet-in-wet, slightly – but not too smoothly – blending the edge between one tone and the next. Mix white and a little Naples yellow for the highlight on the rim of the jar.

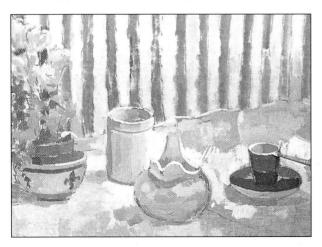

Continue to work around the painting, blocking in broad areas of tone and colour and then blending them together. Paint the greenish shadows inside the egg cup, and beneath the saucer, with a combination of yellow ochre plus a little black and white. Then use your Naples yellow and white mix to paint the highlit rims of the jug and the egg cup.

Squint up your eyes and look for the subtle changes in hue and tone in the glazed surface of the jug, which picks up and reflects colour from its surroundings. Use the no. 4 sable brush to touch in patches of colour - pale mauves, blues and pinks, greenish grevs and bluish grevs - using all the colours previously mixed on your palette. Then finish off the white cloth, using pure white for the lightest areas, modifying it with blues and greys from the

palette for the shadows. In this detail you can see how the artist has broken down the jug into separate 'patches' of colour. Each one is accurately observed in terms of shape, colour and tone, then its colour is mixed on the palette and applied decisively with brush strokes that follow the form of the jug. The separate tones are blended slightly, but not too much, thus retaining a lively paint quality. Note how the brightest highlights are modified with hints of Naples yellow and ultramarine so that they don't appear too stark.

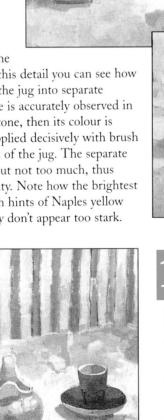

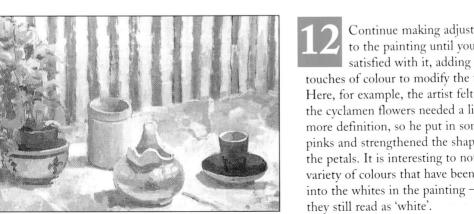

Continue making adjustments to the painting until you are satisfied with it, adding tiny touches of colour to modify the tones. Here, for example, the artist felt that the cyclamen flowers needed a little more definition, so he put in some dark pinks and strengthened the shapes of the petals. It is interesting to note the variety of colours that have been put into the whites in the painting - yet

Painting Trees

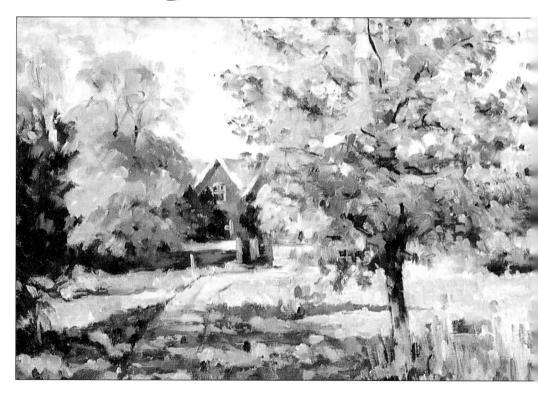

Ted Gould

AUTUMN TREES

Trees in their glorious autumn colours are captured expressively here with thick dabs and strokes of broken colour. Touches of blues and violets make the warm golds really 'sing'.

In a landscape, trees are usually seen from a distance; thus it is more important to capture their overall shape than to try to render every leaf and twig. Try to define the silhouette and 'gesture' of the particular tree species you are painting; an oak tree, for example, has a squat,

rounded shape, while a poplar has a tall, distinctive, conical shape.

It is always necessary to simplify to some extent, whether you are painting bare winter trees or foliage-clad summer ones. Look for the large shapes and masses which characterize the tree and block these in broadly with thin paint, noting how each mass is modelled by light and shade. Then use thicker paint to develop the smaller branches and clumps of foliage. Finally, use descriptive brushwork to suggest some of the nearer foliage masses with more definition, and indicate one or two limbs and branches. The most important thing is to express the idea

of the tree as a living, animate thing, so keep the edges of the foliage soft and feathery by merging them into the background wet-in-wet.

Proportions

A common mistake is misjudging the size of the leaf canopy in relation to the height of the trunk. Often it is painted too small, making the trees look like lollipops. Establish the correct proportions by comparing the width of the canopy with its height from base to crown, then comparing the height of the visible trunk to the overall height of the tree.

Form and volume

Use light and shade to define the volume of trunks, branches and individual clumps of foliage; without attention to this aspect, your trees will appear flat and one-dimensional. Careful observation will show you that the light side of the tree will pick up warm colours, whereas the shadow side will contain hints of blue and violet

reflected from the sky. Note also that not all the branches grow sideways; some will extend towards and away from you.

Sky holes

A tree is seldom, if ever, a solid mass of green. Even when a tree is in full foliage, there are always little light patches where the sky shows through, particularly around the outer edges of the branches. These 'sky holes'

can be painted in last, which gives you a chance to redefine the shapes of the clumps of foliage.

Foliage colours

Try to see how many different colours you can find in the trees around you. Green is often the dominant colour, but the particular hue of green depends on the specific tree as well as on the season, the weather and the time of day. The foliage and branches of trees in spring often contain light greens, greys and even pinks. The full trees of summer contain rich, saturated greens, browns and rusts.

David Curtis SLEET AND SNOW, HATHERSAGE

Trees devoid of their summer foliage make dramatic shapes against a wintry sky. Here the thin, delicate twigs and branches are suggested with feathery drybrush strokes, working the outlines into the sky area to soften them.

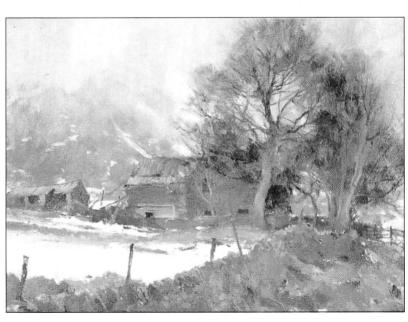

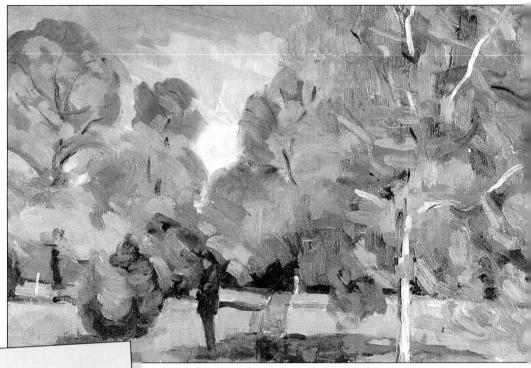

YOU WILL NEED

- Canvas board, 16 x 12in (40.6 x 30.5cm)
- No. 2 round bristle brush
- No. 5 flat bristle brush
- No. 4 long flat bristle brush
- ✓ Charcoal
- **V** Rag
- ✓ Distilled turpentine
- ✓ Purified linseed oil

Autumn Trees

Landscapes and trees are favourite subjects for all oil painters, especially beginners. In this project we show you how to capture the essential characteristics of trees, their forms and textures, by using a variety of brush techniques to lend vitality and movement to your painting. Use bold, broad

OIL PAINTS IN THE FOLLOWING COLOURS

- Spectrum yellow
- Yellow ochre
- Indian yellow
- Chrome orangeCobalt violet
- French ultramarine
- Manganese blue
- Chrome green
- Titanium white
- Mauve

strokes to develop the trunk and branches, and descriptive brushwork for the foliage.

Using a no. 2 round bristle

Lightly sketch in the main outlines of the trees with a thin stick of charcoal. Use a clean cloth to gently flick off any excess charcoal dust so that it doesn't mix with the oil colours and dirty them.

brush, mark in the main areas of the painting with mixtures of cobalt violet, French ultramarine, chrome green and yellow ochre. Dilute the paint with turpentine to a thin consistency and scrub it into the weave of the canvas. Add the outline of the figure in the foreground.

Block in the sky using a no. 5 flat

sky using a no. 5 flat bristle brush and a varied mix of white, manganese blue and French ultramarine diluted with turpentine. As you paint, use your colours only parti

your colours only partially blended to add texture to the sky. Darken the mix with more ultramarine and a little yellow ochre and indicate the trees in the distance. Note how the artist has used vigorous, diagonal brush strokes which suggest the movement of the trees in the breeze (see detail above).

Mix a warm brown from cobalt violet and Indian yellow and block in the main clumps of foliage on the righthand tree. Twist and turn your brush to make both vertical and horizontal strokes. Dilute the paint with about 40% linseed oil and 60% turpentine. This makes the paint richer and easier to work with.

Helpful Hint
DON'T HOLD THE BRUSH TOO
CLOSE TO THE METAL FERRULE AS
THIS RESTRICTS MOVEMENT. HOLD
IT WHERE IT FEELS NATURALLY
BALANCED SO THAT YOUR BRUSHMARKS WILL BE CONTROLLED
YET CONFIDENT.

Mix yellow ochre and Indian yellow for the autumn foliage on the trees. Add in a little chrome orange, chrome green and spectrum yellow. Work across the painting using varied combinations of green, yellow and orange, gradually filling in all the areas of foliage.

Now start painting the foreground using a no. 4 long flat bristle brush. Mix cobalt violet, ultramarine and chrome green to paint the darker, shadowy areas around the base of the trees and on the tree trunks. Mix a lighter green from ultramarine and chrome green for the light-struck foliage near the tops of the trees. Paint the fir trees in the foreground with the darker mix, adding some white to give the effect of light on the trees. Mix spectrum yellow with chrome green and yellow ochre for the grass, varying the proportions of each colour to add variety of tone and texture.

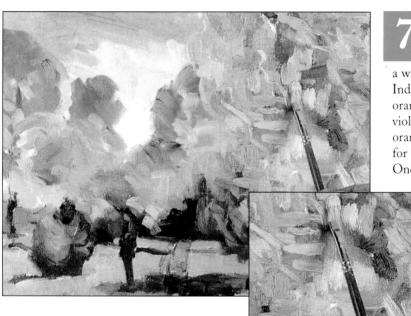

For the track in the centre of the picture mix a warm brown from Indian yellow, chrome orange and cobalt violet. Mix yellows, orange and a little violet for the autumn leaves. Once again vary the

tones and move the brush vertically and horizontally across the canvas to build up an energetic paint surface (see detail left).

Paint the righthand tree trunk and branches with titanium white, letting the colour underneath break into it. Using the no. 2 round bristle brush, now add the dark trunk and branches using a mixture of ultramarine and mauve. Define the figure in the foreground with the same mixture. Finally, move around the picture adding touches of colour to introduce more detail and texture.

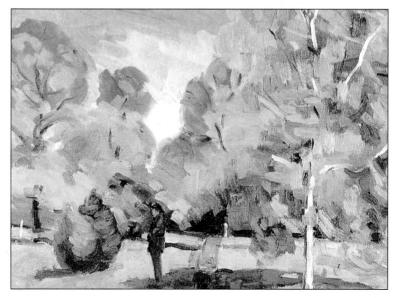

Underpainting

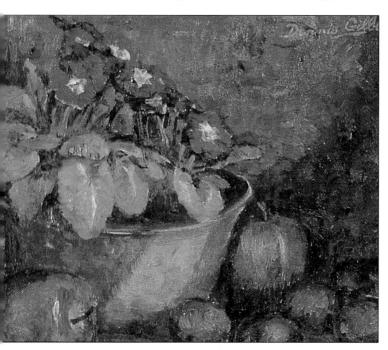

Dennis Gilbert
RED STILL LIFE
When tackling an intricate
subject like this one, starting
with an underpainting can help
by providing a tonal 'blueprint'
of the final image. Knowing
that the composition and tonal
values are sound, you can
proceed with confidence and
thus retain the freshness of
your first impression.

The traditional way of starting an oil painting is to block in the main shapes, masses and tones of the composition with thin paint in a neutral colour, before adding the main details and surface colours and textures. The basic principle is to give you an idea of what the final image will look like before you begin the painting proper.

Composition, drawing, proportion, the distribution of light and shade – all of these elements can be checked, and any alterations made quite easily at this stage. Because the paint used for underpainting is so thin, any alterations needed can be easily effected by wiping the paint with a rag soaked in turpentine; this will not be possible in the subsequent

stages, as you run the risk of overworking the painting and spoiling the colour mix.

The result is a practical division of labour; once the underpainting is complete you can begin working in colour,

confident that the composition and tonal values are sound. This is the time-honoured method of painting in oils, which was used by Rembrandt, Rubens and many other great masters.

When underpainting in oils, always keep in mind the principle of working 'fat over lean': the paint should be thinly diluted with turpentine and allowed to dry thoroughly before adding further layers. To save time, fast-drying colours such as raw umber, cobalt blue and terre verte are the most convenient to use.

Alternatively, use acrylic paint for the underpainting. This dries within minutes, allowing you to begin the overpainting in oils in the same session.

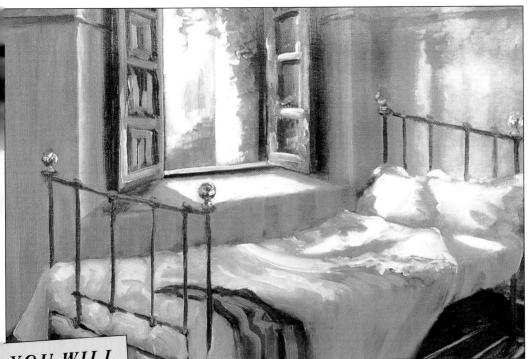

YOU WILL NEED

Sheet of primed canvas board, 161/2 x 12in (41.9 x 30.5cm)

3/4in (19mm) flat synthetic fibre brush

No. 4 flat synthetic fibre brush

No. 6 flat synthetic fibre brush

HB pencil

Distilled turpentine

Small piece of muslin

Kitchen paper

The Boudoir

It was important to assess the light and dark tones accurately in order to recreate the effect of vibrant light in this sunny interior. By starting with an underpainting, the artist was able to control the tonal balance of the image from the beginning, without being distracted by colour. Tones of blue-

OIL PAINTS IN THE FOLLOWING COLOURS

- Monestial turquoise

 Burnt sienna
- Monestial blue
- French ultramarine
- Indigo
 - Winsor violet
- Brown ochre
- Yellow ochre
- Lemon yellow Rowney red

grey were used for the underpainting, to harmonize with the cool, shadowy tones of the bedroom.

OIL PAINTING

When painting a complex subject, it's a good idea to make a pencil sketch of it first. Refer to the sketch as you paint, using it to check the perspective lines and the arrangement of light and dark tones. Drawing a grid over the sketch (use tracing paper if you prefer) makes it easier to transfer the composition to your canvas; draw a grid in the same

proportions on the canvas, then transfer the image that appears in each square on the sketch to its equivalent square on the canvas.

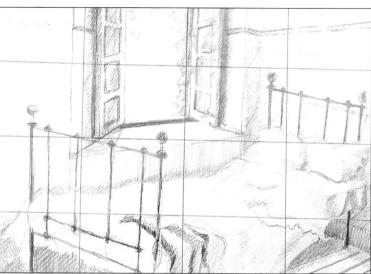

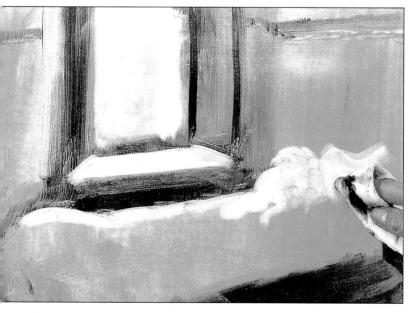

Mix a wash of monestial turquoise, thinly diluted with turpentine, and apply this over the entire board with the 3/4in (19mm) flat brush. This eliminates the stark whiteness of the primed canvas board. Add a touch of indigo to the mixture and block in the dark tones - the window frame, the picture rail and the shadows around the bed. Now wrap a piece of muslin round your finger, dip it in turpentine and rub into the wet colour, back to the white priming, to introduce the light tones on the window and the bed. Here we see how the artist has described the rumpled sheets and pillows by 'drawing' into the wet paint with the muslin. The tone of the wall on the right has also been lightened. Now, using the chisel edge of the no. 4 flat brush and the monestial turquoise and indigo mixture, put in the lines on the window shutters and paint the metal bedstead.

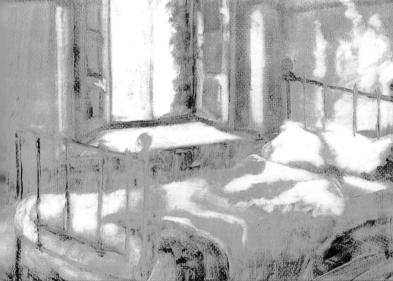

Helpful Hint

AS YOU WORK, KEEP CHECKING ONE DARK AREA AGAINST ANOTHER TO SEE WHETHER OR NOT THE TONES ARE SIMILAR, THEN CHECK THEM AGAINST THE LIGHTER AREAS. OVER-ESTIMATING THE DIFFERENCES BETWEEN TONES CREATES A CONFUSED, 'JUMPY' IMAGE. ALWAYS KEEP AN EYE ON THE WHOLE IMAGE AS WELL AS INDIVIDUAL PARTS.

Build up an informative under-painting, adding the details on the shutters and bedstead with broad brushstrokes. Start to refine the broad shapes of light and dark on the bed linen and the dressing gown draped over the foot of the bed. Add a little more indigo to the

mix and loosely describe the foliage glimpsed through the window. Suggest the frilled edges of the sheets and pillows by working into the wet paint once more with the damp muslin, pushing your fingernail through to the cloth to describe the intricate curves.

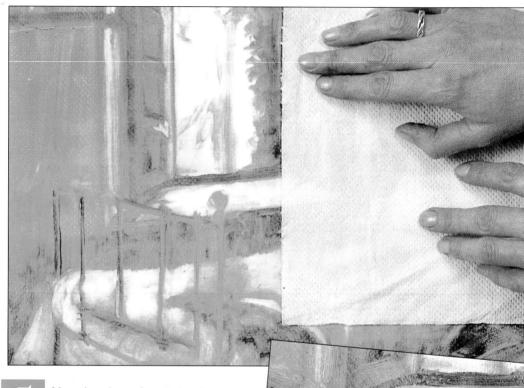

Now that the underpainting is completed you can start to build up the details. To create a surface with more 'grip' for the further application of paint, try the following technique: lay a sheet of absorbent paper such as kitchen paper over the painting and gently smooth it down using a circular movement. Then peel away the paper to remove any excess oily paint, creating a more sympathetic surface to work on. Leave the painting to dry for approximately 24 hours. This method is known as 'tonking' (after a former professor of painting named Henry Tonks). In the detail (right) you can see how the tonking

method creates a pleasing, softly textured surface. The main structure of the painting is firmly established, but the colours are softened and lightened, making it easier to continue adding more detail on top.

UNDERPAINTING

Now start to introduce the warm tones in the room. Partially mix titanium white, Winsor purple and brown ochre. Using a no. 4 flat brush, sketch in the view through the window with loose, fluid brushstrokes, working the colours wet into wet. Use pure white on the sunlit wall. Add warm highlights on the sunlit leaves with white

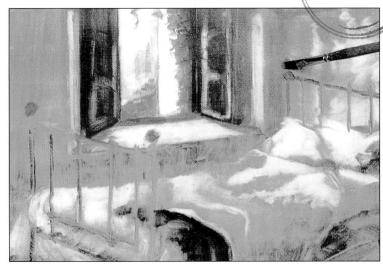

and a little yellow ochre. For the shadowy leaves use monestial turquoise and monestial blue. Paint the wooden shutters with a thin wash of burnt sienna. Touch in the knobs on the bedstead with brown ochre.

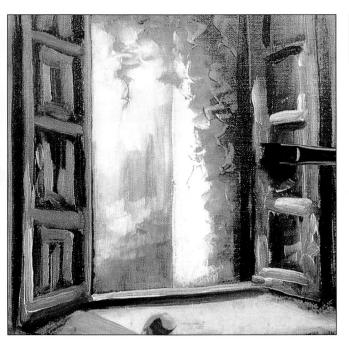

To make the view through the window appear to recede, concentrate stronger detail and colour on the window itself to bring it forward. Block in the shutters with a mix of raw umber and indigo. Then mix vellow ochre, burnt sienna and white and define the carved detailing on the shutters. Where warm light strikes the edges of the shutters, use a warm orange mixed from Rowney red, yellow ochre and lemon yellow. For the cooler glints of light, add touches of white and lemon yellow. Paint the shadows cast by the shutters on the windowsill with monestial turquoise and indigo.

Sunlight streaming in through the open window gives the shadows on the walls a luminous blue-violet tint. Use a no. 6 flat brush to paint the walls with monestial turquoise and white, working in some Winsor violet and white for the shadow areas. For the shadow on the wall beneath the window, mix indigo and Winsor violet. Paint the window alcove with a mix of monestial blue. white and a touch of ultramarine. Sketch in the picture rail with a mix of indigo and burnt umber and define the edge of the window alcove with white and lemon yellow.

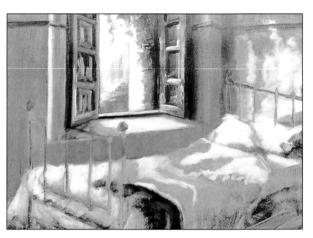

Soften the colour of the wall on the right with a mix of ultramarine and white. Work into the shadows under the bed with indigo and a little raw umber, then scratch lines into the wet paint with the end of the brush handle to suggest the floorboards. With the no. 4 brush, define the metal bedstead with indigo. Mix lemon yellow with just a touch of Rowney red and dot in the bright highlights on the shiny brass bed knobs.

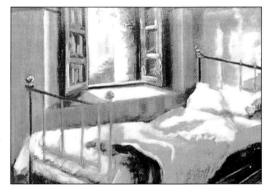

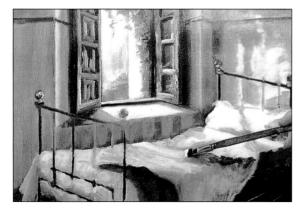

Now start to define the cool shadows and warm lights on the white bed linen. Go over the shadows established in the underpainting with shades of ultramarine and monestial blue. Where the sheet folds over the end of the bed the shadows have a more violet cast – paint these with a mix of Winsor violet and white. Then mix white and yellow ochre to pick up the highlights on the pillows and sheets.

Suggest the striped pattern of the dressing gown with Rowney red and a mix of monestial blue and white. Finish defining the bedstead with indigo and complete the brass knobs with raw umber for the shadows, a little Rowney red for the reflections and lemon yellow for the bright highlights. Deepen the shadow on the sheet falling over the edge of

the bed with a mixture of ultramarine, Winsor violet and white. Mix white with just a hint of ultramarine and begin painting the brighter whites where light from the window is shining directly on to the bed.

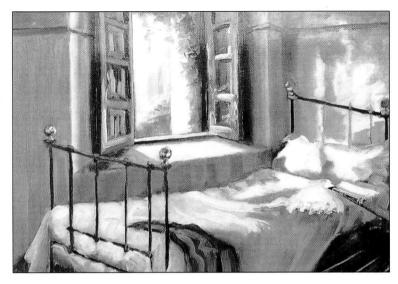

Helpful Hint

WHITE OBJECTS REFLECT COLOUR FROM THEIR SURROUNDINGS, SO THEY RARELY APPEAR PURE WHITE BUT A COMPOSITE OF MANY COLOURS. IN THIS SUNNY ROOM THE WHITE BED LINEN CONTAINS COOL BLUES AND VIOLETS IN THE SHADOWS AND WARM CREAMS AND YELLOWS IN THE HIGHLIGHTS.

Use the same mixture to paint the pillows and suggest their frilled edges, and to soften and blend the shadows and highlights on the righthand wall. Finally, use touches of pure white to accentuate the dappled light that falls across the windowsill and over the bed.

Developing the Painting

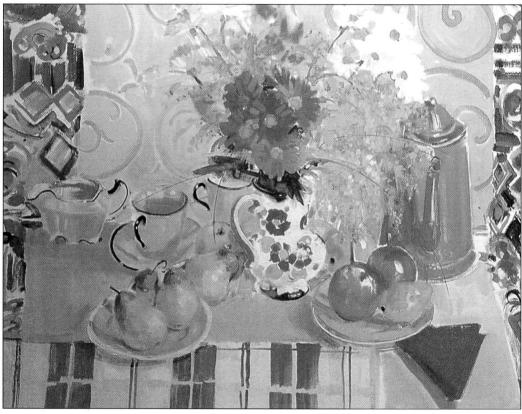

Peter Graham

LE PETIT DÉJEUNER

This artist always starts his paintings with washes of thin colour, well diluted with turpentine, to indicate the broad forms of the composition. By building up the colours gradually, he keeps the final painting fresh and lively.

A mistake sometimes made by inexperienced painters is to work on one small area of a paint-

ing until it is 'finished', and then move on to the next area. However, this can result in a confused and disjointed image because each area of tone and colour is separate and unrelated to its neighbours.

Instead of working in this piecemeal fashion, try to work over all areas of the canvas at the same time, moving from foreground to background and letting the composition weave itself into a whole. The image should emerge gradually, similar to the way a photographic image comes into focus in the developing tray.

DEVELOPING THE PAINTING

Balancing colours

Keep your eyes moving around the subject, looking for the way tones, colours and shapes relate to each other and making adjustments as you go. You need to do this because the tones and colours you apply to your canvas do not work in isolation – they are influenced by the tones and colours surrounding them. For example, a tone which appears dark on its own will suddenly appear much lighter when surrounded by darker tones. Similarly, a warm colour may appear quite cool when surrounded by even warmer colours. Painting is a continuous process of balancing, judging, altering and refining – which is what makes it so absorbing.

Building up

If you apply too many heavy layers of paint in the early stages, you may find that the surface quickly becomes clogged and the paint eventually builds up to a slippery, churned-up mess. To avoid this you need to pace yourself in the early stages – it is a mistake to try to get to the finished picture too soon.

When you start a painting, bear in mind the advice of Cézanne: "start with the broom and end with the needle!" In other words, work from the general to the particular. Start by rapidly laying in the broad shapes and colour masses of the composition with thin colour before starting to develop the detail.

Dennis Gilbert

WASHING LINE, MURANO

The harmony and unity of this picture was achieved by working over the whole painting at once, so that colour was picked up on the brush and transferred to other areas, thus allowing the image to emerge gradually from the canvas.

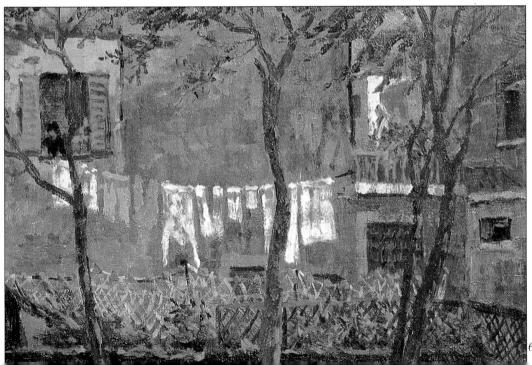

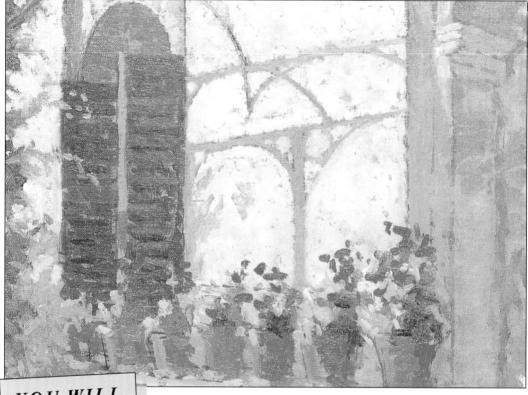

YOU WILL NEED

- Sheet of primed board, 20 x 16in (50.8 x 40.6cm)
- No. 3 round sable bristle brush
- No. 4 round bristle brush
 - No. 6 round bristle
- Distilled turpentine
 - Purified linseed oil
 - Dammar varnish

Terrace in Tuscany

A successful composition weaves itself into a whole. To capture the unifying effect of bright sunlight on this scene, the artist worked over the

OIL PAINTS IN THE FOLLOWING COLOURS

- Raw umber
- Raw sienna Burnt sienna
- Cadmium orange
- Yellow ochre
- Chrome green Cadmium red
- Alizarin crimson

- Titanium white
- French ultramarine
- Ivory Black
- Viridian
- Lemon vellow
- Cobalt blue Vermilion

whole painting at once, so that paint was picked up on the brush and transferred to other areas of the canvas.

Prepare your board in advance by tinting it with a warm brown mixed from raw umber and raw sienna. Dilute the paint with plenty of turpentine and apply it loosely with a 1in (25mm) decorating brush. Leave to dry for 24 hours. Using a no. 3 round sable brush, draw the main outlines of the composition with thinly diluted burnt sienna.

Start to block in the stone wall of the house with a light golden yellow mixed from varied combinations of cadmium orange, yellow ochre and titanium white. Mix the paint with a medium consisting of equal parts of linseed oil and dammar varnish plus twice the volume of turpentine. Apply the paint with a no. 6 round bristle brush using short brushstrokes worked in different directions. Allow some of the background wash to show through.

Paint the climbing plant on the left with a mixture of French ultramarine, chrome green and ivory black, varying the tones from light to dark. Suggest the slatted wooden shutters with a mixture of burnt sienna, alizarin crimson and a little cadmium red. To paint the part of the wall that falls in shadow on the right you will need chrome green, burnt sienna, alizarin crimson, cadmium red and French ultramarine. Mix the colours in varying combinations to create a variety of tones ranging from grey to a greenish brown.

Mix burnt sienna, cadmium red, alizarin crimson and white to make a rich terracotta and use this to rough in the shadow sides of the plant pots. Paint the arch above the shutters with the same combination of colours used for the shadowy wall in step 3. Use the same mix to suggest the dappled shadows cast by the foliage on the bottom left of the picture.

Continue building up the picture loosely, keeping an eye on the overall effect.

Resume work on the background wall and the shutters, using the same colours mixed earlier. Switch to a no. 4 round bristle brush and define the shadow cast by the pergola onto the wall with a purple-grey mixed from ultramarine and cadmium red. Work on the climber and the geranium leaves, adding a little yellow ochre to the original foliage colour used in step 3 for the warmer tones.

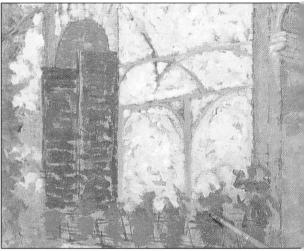

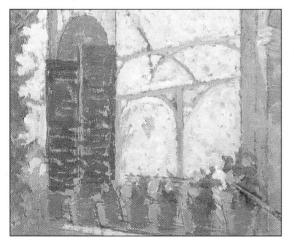

Continue building up the colour on the background wall. Add subtle hints of lighter tone to the shadow of the pergola by adding cobalt blue and a little white to the original mix. Use the same colour for the dappled shadows either side of the shutters. Mix viridian and ultramarine for the small trays under the plant pots. Put in the warm lights on the plant pots with touches of cadmium orange and a dusky pink mixed from alizarin, white and a touch of burnt sienna. Paint the sunlit geranium leaves using white, chrome green and lemon yellow.

DEVELOPING THE PAINTING

Give more definition to the shutters, adding more alizarin to the original mix for the darker slats and a little white for the highlights.

Define the sunlit edge of the shutter with a mix of cadmium orange, lemon yellow and white. Use the same colour to suggest the trailing plant in the lefthand corner.

Mix lemon yellow, chrome green and white for the light-struck leaves on the climber. Use a no. 3 round sable brush to paint the green metal arch of the pergola with a mixture of viridian and ultramarine, lightened with white.

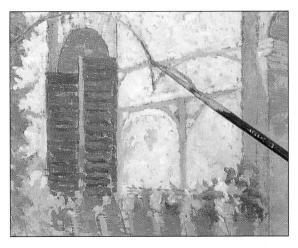

"Helpful Hint as tour painting nears

COMPLETION, TAKE A BREAK FROM IT SO THAT WHEN YOU COME BACK TO IT TOU CAN LOOK AT IT AFRESH. Bring some sprigs of foliage out across the shutter on the left to create a sense of three-dimensional space. Add touches of richer colour to the terracotta plant pots with mixes of burnt sienna, cadmium red and cadmium orange. Finally, paint the brilliant red geranium flowers with short strokes

of vermilion, letting the brushstrokes themselves form the shapes of the petals. This detail (left) of the geraniums illustrates the way paint can be used to create texture. The flowers and leaves

are suggested by short, curving brushstrokes, using thick paint over a stillwet layer beneath it so that each colour is modified by the one beneath.

Impasto

When oil paint is applied thickly and liberally so that it retains the marks and ridges left by the brush, it is called impasto. The technique is often used in alla-prima painting (when the painting is completed in one session) as the thick paint and rapid brushstrokes allow the picture to be completed quickly. The three-dimensional quality of impasted paint can be used to model form and even mimic the texture of an object. Impasto may be used only in small parts of a painting, or an entire painting can be

built up with heavy paint to create a lively, energetic surface.

Impasto can be applied with a brush or a painting knife. The paint needs to be of a buttery consistency and may be used straight from the tube or diluted with a small amount of turpentine or medium so that it is malleable, yet thick enough to stand proud of the support.

Bristle brushes are best for impasto work because they hold a lot of paint and are tough enough to withstand a lot of wear and tear.

Ted Gould

GARDEN IN SPRING

Left: This impasto painting is composed entirely of thick, swirling brushmarks, applied with brushes and painting knives. Alastair Adams

SHEEP

Below: Here, small touches of impasto are used to highlight the thick woolly coats of sheep and provide a contrast with the smooth paint beneath.

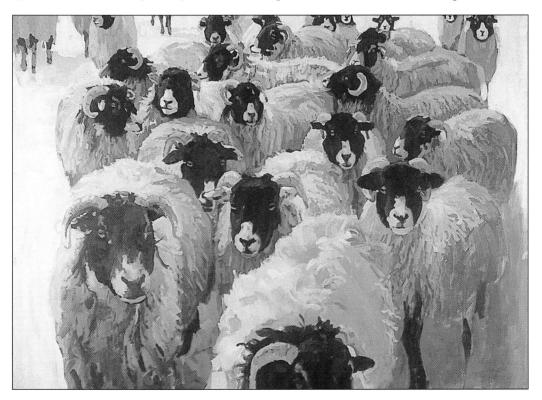

YOU WILL NEED

- Canvas board, 14% x 12in $(36.8 \times 30.5 cm)$
 - No. 4 filbert bristle brush
 - No. 5 flat bristle brush
 - No. 2 round bristle hrush
 - No. 4 flat sable brush
 - Distilled turpentine
 - Refined linseed oil
 - Charcoal
 - ✓ Clean rag

Garden in Spring

The vibrant impact of this painting is very much a result of the impasto technique, which involves a thicker than normal use of paint. Impasto emphasizes the artist's brushstrokes, giving a sense of movement and vitality to the whole picture surface and creating an interesting range of textures.

OIL PAINTS IN THE FOLLOWING COLOURS

- Chrome greenLemon yellow
- French ultramarine
 Cobalt violet
- Cadmium red Manganese blue
- Spectrum yellow
- Yellow ochre
- Titanium white

Lightly sketch in the main outlines of the composition with charcoal, dusting off any excess with a clean rag so that it doesn't mix with the paint colours and dirty them.

Helpful Hint

WITH A COLOURFUL SUBJECT LIKE THIS ONE, IT'S A GOOD IDEA TO START BY BLOCKING IN THE BROAD COLOUR AREAS OF THE COMPOSITION WITH THIN PAINT. THIS GIVES YOU A KEY AGAINST WHICH TO JUDGE SUBSEQUENT TONES AND COLOURS.

Now begin the underpainting, to establish the broad areas of colour. Dilute the paint with turpentine to get a thin consistency, and apply it with a no. 4 filbert bristle brush. Paint the pale green grass in the foreground with chrome green and, for the violet blue of the forget-me-nots, use a combination of French ultramarine and manganese blue. The mellow tones of the garden shed are created with yellow ochre and spectrum yellow, while

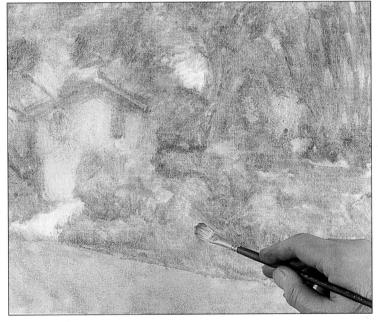

chrome green, cobalt violet, yellow ochre and a little cadmium red create a subtle patchwork of hues for the trees and shrubs. Stand back to assess the composition. Leave the painting to dry.

OIL PAINTING

Use the paint thickly now for the darkest tones in the picture, adding just enough turpentine/linseed oil medium to give it a creamy consistency. For the deepest darks in the trees, and the windows of the garden shed, loosely mix cobalt violet, French ultramarine and chrome green. Use pure chrome green for the warmer greens in the foliage where light filters through the trees. Use a mix of cobalt violet and cadmium red for the shadow beneath the shed roof. Twist and turn the brush as you work, to produce a range of marks and textures.

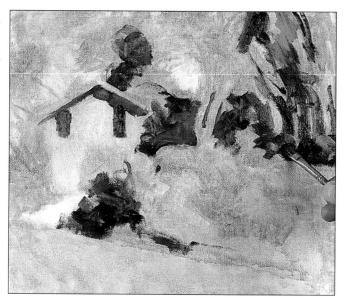

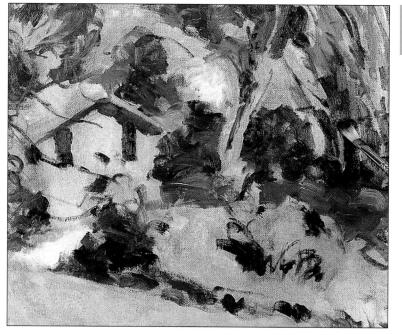

Don't try to complete any one area of the composition before the rest, but move across the painting and build up the colours overall. Introduce splashes of warm colour to the trees and shrubs to give the impression of warm sunlight; mix cobalt violet and cadmium red with a little white and apply the paint with bold brushstrokes.

To create the lighter tints of the garden shed, mix cadmium red, spectrum yellow and titanium white to give a warm orange. Load a no. 5 flat bristle brush with paint and use it like a spatula, applying broad strokes of colour that retain the marks of the brush. Vary the tints by altering the proportions of colour in the mix, adding more yellow to give the effect of dappled light or more white for the highlights. For the shed roof, use cobalt violet and white.

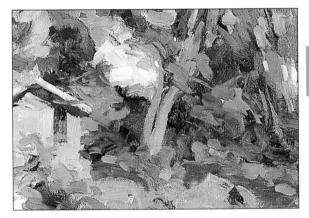

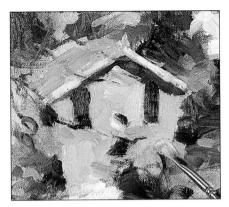

Mix French ultramarine with chrome green and loosely define the forms of the trees in the background, ignoring the detail. For the buildings just glimpsed behind the trees, use cadmium red mixed with white to give a warm pink. Add some white and a little yellow ochre to the mixture and use it to give touches of light within the trees and to define the main tree trunk.

Mix yellow ochre, cobalt violet and white to create the warm tone of the path running along the side of the garden. Clean your brushes by dipping them in turpentine and wiping them on a rag. Mix white with manganese blue and suggest the clumps of forget-me-nots using thick paint and lively brushstrokes. Create the effect of dappled light by adding a little French ultramarine to the mixture and touching in a few shady areas. Darken the mixture with a touch of cobalt violet for the forget-me-nots in the shade of the trees in the background.

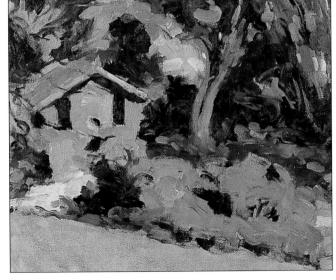

Now start to bring out the forms of the individual clumps of foliage. Mix chrome green, ultramarine and a touch of white for the cool, mid-tone greens of the trees on the right. Suggest the foliage masses with broad strokes of a no. 5 flat brush, using the edge as well as the body of the brush. In this close-up detail you can see the range of lively marks the artist has made, and how the thick paint gives texture and form to the individual elements of the composition.

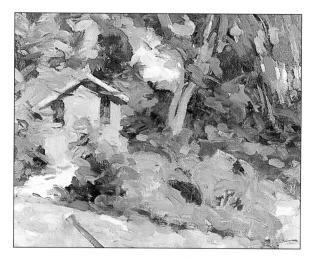

For the foreground grass, mix chrome green, lemon yellow and white, varying the proportions to create light and dark tints that suggest the play of dappled light. Add lemon yellow to the same green and use it to suggest the sunlit foliage around the shed, making short, curved strokes with a no. 2 round bristle brush. Mix yellow ochre, spectrum yellow and white to suggest bare patches of earth in the grass.

To create a cooler green in the shadows, mix chrome green, white and ultramarine and apply it with a no. 5 flat brush. Then mix a bright, warm green from lemon yellow, chrome green and white and paint the patches of brightly lit foliage with short strokes and dabs of a no. 2 round brush and a no. 4 flat sable brush. Add some cobalt violet to the mixture and dab it into the shadows on the forget-me-nots beneath the trees so that they subtly echo the strongest colour of the painting.

Mix white and manganese blue and dot in the highlights on the forgetme-nots. Use lively brush strokes to break up the area of foliage in the centre of the painting and create the effect of dappled sunlight in the trees. Make the colour of the highlights slightly warmer in places by adding a little cadmium red, spectrum yellow and yellow ochre.

Helpful Hint

YOUR PALETTE CAN BECOME VERY MESSY WHEN PAINTING WITH OILS AND IF TOO MANY COLOURS GET MIXED TOGETHER THEY WILL LOOK MUDDY. IT PAYS TO CLEAN YOUR PALETTE AS SOON AS THIS STARTS TO HAPPEN.

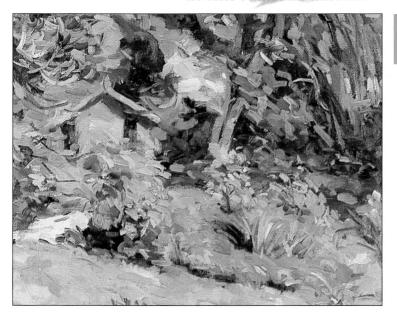

Stand back and assess the painting, then add any necessary finishing touches - maybe striking in a few strokes of hot colour to enliven the painting and offset the green foliage, or giving definition with touches of deeper colour. Use different sized brushes so that the variety of brushmarks gives textural interest to the paint surface.

Knife Painting

John Denahy
SHOREHAM VALLEY
Painting knives are
capable of producing very
delicate effects as well as
bold ones. Here the artist
used the edge of the knife
with a very thin, flexible
blade to 'print' the white
lines of the wire fencing.

Knife painting is a versatile and expressive method of building up layers of thick impasto to create a richly textured paint surface. Knives are also ideal for working alla prima – when you paint fast, directly and boldly, completing the picture in one single layer of paint.

Types of knife

Painting knives are not the same as palette knives, which have a straight handle and a long, straight blade and are used for mixing paint on the palette and for cleaning up. A painting knife has a very springy, responsive blade and a cranked handle to prevent the knuckles accidentally brushing against the canvas when applying the paint. Knives are

available in many different sizes and shapes, including trowel, diamond and elliptical, for creating a range of textures and effects.

Techniques

Painting with a knife is initially trickier than painting with a brush, so it is wise to practise until you get the feel of it. You can apply the paint in broad sweeps with the flat of the knife, or use the tip to get sharp, angular marks and you can lift the knife to create a rough, stippled texture. You can even skim paint off with the edge of the blade to leave a very thin stain, or use the sharp tip of the blade to scratch through a layer of wet paint and reveal the colour underneath.

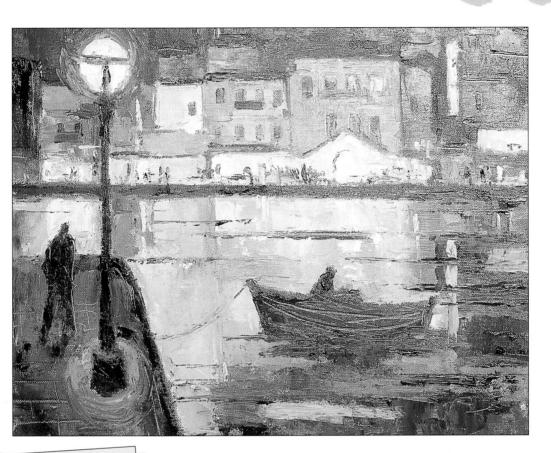

YOU WILL NEED

- Sheet of canvas board, 161/2 x 14in $(41.9 \times 35.6cm)$
 - Trowel-shaped painting knife
 - No. 6 flat bristle brush
 - No. 2 flat bristle brush
- Distilled turpentine
- Purified linseed oil

Chania at Night

Applying paint with a knife forces you to work boldly to create a type of impasto painting. The knife spreads paint over the surface quickly, and the smeared, ridged paint creates a lively surface texture.

OIL PAINTS IN THE FOLLOWING COLOURS

- Alizarin crimson
- Spectrum yellow
 French ultramarine
 Purple lake

- Yellow ochre
- Titanium white
- Cobalt violet

Before you start to apply the paint with the knife, make a monochrome underpainting to act as a compositional guide. Using French ultramarine and purple lake thinly diluted with turpentine, block in the main elements of the scene using a no. 6 flat bristle brush. Add more turpentine to lighten the colour for the mid-tones, and leave areas of bare canvas for the lightest tones. Use a no. 2 flat bristle brush to sketch in the figures and the details on the buildings. Leave the painting to dry for two to three hours.

From this point on, use thick paint mixed with just a little linseed oil/turpentine medium.
Start by putting in the bright café lights along the harbour front, and their reflections in the water, using various combinations of titanium white, yellow ochre and spectrum yellow. Add a little alizarin crimson for the deeper tones. Apply the paint thickly with the painting knife, angling it horizontally and vertically to give movement to the water. Use the tip of the blade to work the paint around the figure in the boat.

UP THE PAINT TOO THICKLY, SIMPLY SCRAPE OFF THE WET PAINT WITH THE EDGE OF THE PAINTING KNIFE.

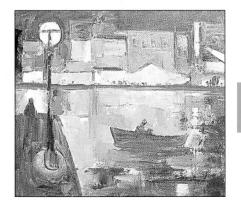

Use the knife to define the buildings with blocks of varying tone and colour. Use the same yellows mixed in step 2, adding a little purple lake or alizarin crimson for the darker toned buildings. Use the dark mixture for the reflection in the water on the far right, scraping the paint on thinly so it breaks up on the canvas surface.

For the dark reflections in the immediate foreground, use warm tones made up of yellow ochre, spectrum yellow, crimson and purple. Mix white and a little ultramarine for the silvery reflections beneath the harbour front. Paint the pool of bluish light at the base of the street lamp with a mixture of ultramarine, white and a touch of purple. For the lamp itself, use white broken with a little blue and purple - pure white would appear too stark and unnatural. Then add broken strokes of pale blue around the lamp to make it appear to glow.

Artificial lights usually appear to have a bright centre surrounded by a fainter glow. In this detail we see how the artist has reproduced this effect by adding a 'halo' of blue around the lamp to blend it into the surrounding atmosphere.

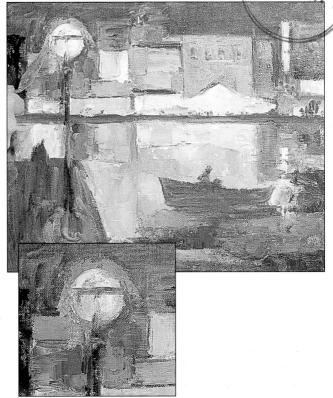

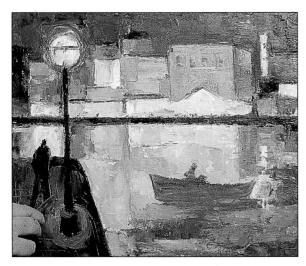

Paint the night sky with deep blues mixed from ultramarine, purple and a little white, varying the tones to suggest the lights reflecting up into the sky. Darken the mix with alizarin and cobalt violet and define the line of the harbour front and the quayside, lamp post and figure in the foreground. Pick out the highlights on the figure, and suggest the paving stones, by scratching into the wet paint with the edge of the knife blade.

OIL PAINTING

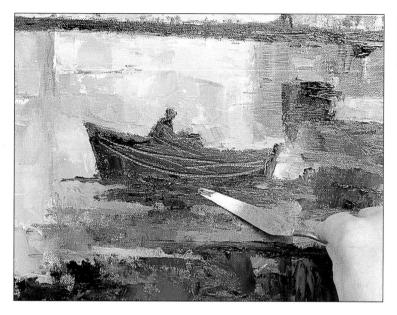

Mix the ultramarine and purple and deepen the reflections created by the boat. Add white to the mix and suggest some lighter ripples with the tip of the knife. Define the boat and the figure with a dark mix of ultramarine and violet, then scratch into the wet paint with the edge of the knife blade to suggest the texture of the wood.

Pick up some violet on the edge of the knife and apply horizontal lines with a press-and-lift motion to suggest the dark ripples in the water. Add the rope attaching the boat to the quayside with the same colour, using the tip of the knife. Use spectrum yellow to paint the brightest reflections in the water, smearing paint on with vertical strokes of the knife.

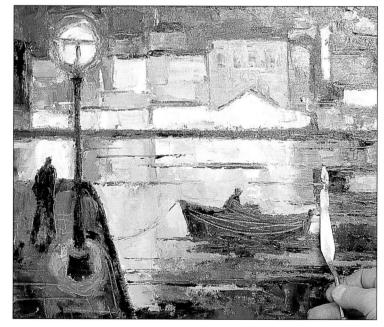

Pick up some purple lake on the tip of the knife and jot in a series of small, broken marks along the harbour front to suggest the hustle and bustle of the outdoor cafés silhouetted against the bright lights.

Helpful Hint
ALWAYS WORK FROM
THE GENERAL TO THE
PARTICULAR. LAY IN THE
BROAD SHAPES AND MASSES
FIRST, AND ONLY THEN
WORK ON THE DETAILS.

To complete the painting, switch to a no. 2 flat bristle brush and paint the windows in the buildings with varied tones of ultramarine and purple.

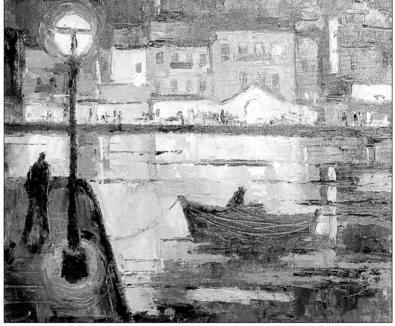

Colour Harmony

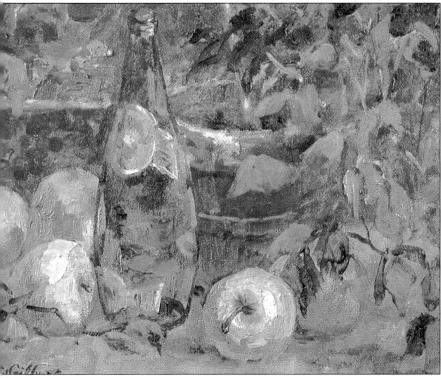

Dennis Gilbert
GREEN STILL
LIFE
The cool greens and
yellows in this
painting are offset
by smaller touches of
warm earth colours;
thus the image is
harmonious but not
monotonous.

Think of the tones and colours in a painting as musical notes. If you include too many colour 'notes' in your picture it becomes confused and 'out of tune'. But if you use them in a controlled range, you will produce an image that is not only balanced and harmonious but also more powerful and intense.

Analogous colours

An effective way of creating harmony in a painting is to focus on a small selection of colours which lie next to each other on the colour wheel; these are called analogous colours. They work together well since they

share a common base colour. Examples of harmonious colour schemes might be blue, blue-green and blue-violet; or orange, redorange and yellow-orange.

Nature provides ample inspiration for harmonious colour schemes. Think of the golds, russets and reds of an autumn landscape, the subtle shades of blue and green in a river or sea, or the pinks, violets and indigos of the sky at twilight.

There is a risk, of course, that too much harmony can make a rather bland, insipid painting. One way to avoid this is to include a small area of contrasting colour in the composition; for example, a painting with a predominant theme of blue might benefit from a touch of a brighter colour such as orange or yellow.

Selective palette

Another way to ensure that there are no jarring notes in your picture is by sticking to a selective range of colours and interweaving them throughout the picture. Using a limited number of colours is an excellent way to learn about colour mixing – you'll be surprised at the wide range of subtle and vibrant hues that can be mixed from just half a dozen colours.

Try to work over the whole painting at once, so

that paint is picked up on the brush and transferred from one area of the composition to another; when a few colours are continually repeated and intermixed in this way, a certain harmony will naturally arise.

Toned grounds

Toning the canvas with a wash of colour is another way of achieving harmony. It is easier to work out a cool colour scheme of blues and greens on a similarly cool blue-grey ground, for example, than on a white ground. The toning strikes through the patches of overlaid paint and becomes an integral part of the picture, pulling together all the various elements.

Colours adjacent to one another on the colour wheel form a related, harmonious sequence.

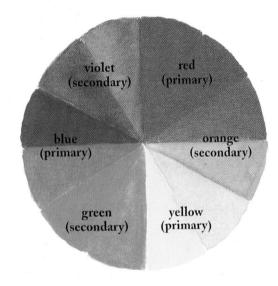

The colour wheel is a handy 'tool' which the artist can refer to when experimenting with colours and the way they react together. It is a simplified version of the spectrum, formed into a circle, showing the arrangement of the primary colours (red, yellow and blue) and the secondary colours (orange, green and violet), from which all other colours are mixed.

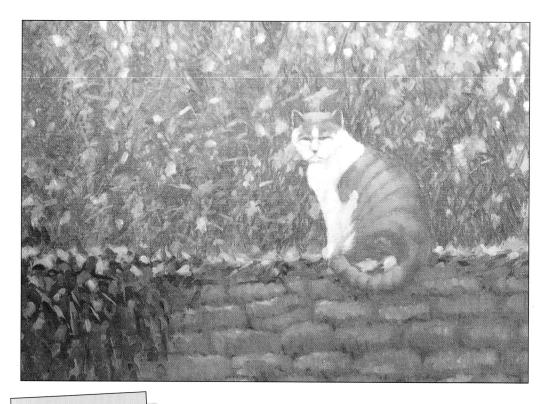

YOU WILL NEED

- Sheet canvas or board, 18 x 14in (45.7 x 35.6cm)
- No. 6 round sable or synthetic brush
- No. 8 round bristle
- Refined linseed oil
- Distilled turpentine
- Lint-free cloth
- ✓ 1½in (38mm) decorating brush

Marmalade Cat

Although this painting contains a lot of complex detail the artist has kept it under control by sticking to a limited palette of related colours. Yellows and oranges predominate, with touches of green providing a foil for the warmer colours. The yellow toned ground strikes through the

OIL PAINTS IN THE FOLLOWING COLOURS

- Yellow ochre
- Burnt sienna
- Cadmium redTitanium white
- Prussian blue
- Cobalt blue
- Lemon yellowCadmium yellow
- Cerulean

overlaid brushstrokes, providing a harmonizing element of its own.

Prepare your canvas in advance by toning it with a wash of yellow ochre, well diluted with turpentine and applied with a 1½in (38mm) decorating brush. Before this dries, rub over the canvas with a clean, lint-free cloth to lighten the colour and soften the brush marks. Leave to dry overnight. This creates a warm, golden undertone that will show through the overlaid colours and harmonize the picture. Sketch the main outlines of the cat and the stone wall. Use burnt sienna thinly diluted with turpentine, applied with a no. 6 round sable or synthetic brush.

Helpful Hint

TO SAVE TIME, WHY NOT TONE THE CANVAS WITH ACRYLIC PAINT? UNLIKE OILS, THIS DRIES IN MINUTES, ALLOWING YOU TO START PAINTING STRAIGHT AWAY. OIL PAINTS CAN BE APPLIED OVER ACRYLICS, BUT ACRYLICS SHOULD NEVER BE APPLIED OVER OILS AS THIS CAUSES THE OIL PAINT TO CRACK.

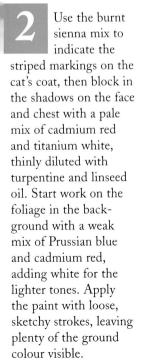

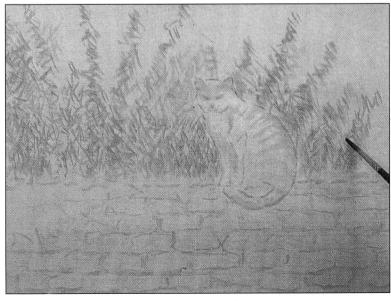

OIL PAINTING

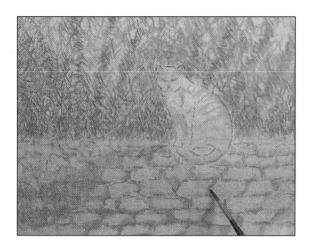

Still using the no. 8 brush, mix white with a hint of cobalt blue and carefully paint the pale greyish-white fur on the cat's face and chest with short brushstrokes. Let the pinkish shadows underneath show through the white. Develop the marmalade stripes with a combination of yellow ochre and cadmium red.

Continue working on the foliage, building up the leaves and branches with short, random brushstrokes. Now use the Prussian blue/cadmium red mixture to define the shadows on the individual stones in the wall, and the shadow cast by the ivy climbing over the wall on the left of the picture.

Continue working up the background using the same colours as before. Vary the direction of your brushstrokes to suggest the scattered effect of the foliage. Build up the shadows on the wall with loose strokes. The paint should still be quite thin at this stage, allowing the toned

ground to show through (see detail). Now make a slightly thicker mix of yellow ochre, cadmium red and white to make a pale peachy colour. Work this loosely into the foliage and on the wall to create soft highlights, flicking the brush gently across the canvas.

Mix lemon yellow, cobalt blue and a touch of yellow ochre to make a dull green and start to paint the ivy creeping over the wall. For the light-struck leaves mix together cobalt blue, lemon yellow and white to make a cool blue-green. For the shadows underneath the foliage use a mixture of Prussian blue, cadmium red, yellow ochre and white. Scumble the colour onto the stone wall, still allowing the toned ground to show through.

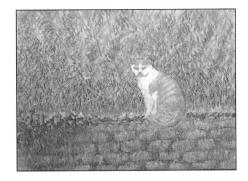

Resume work on the cat, adding more of the cobalt blue/white mix for the fur on the face, neck and chest. For the fur between the ears use lemon yellow and white with a touch of cadmium red. Put in the eyes and nose with a dark pink made up of white and cadmium red with a hint of Prussian blue. For the marmalade stripes use white, cadmium yellow, cadmium red and a touch of burnt sienna. Apply the paint with short feathery strokes to give the effect of soft fur.

Keep moving from area to area, rather than concentrating on one particular part of the painting. Mix lemon yellow and white and work back into the foliage to introduce some warm highlights with loose dots and dashes. Use the same colour on the ivy along the top of the wall.

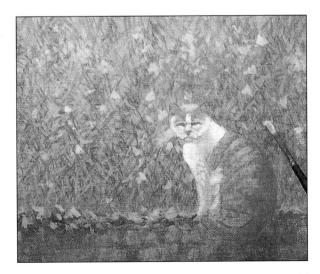

Make a thicker mixture of cobalt blue and lemon yellow to make a rich green and use this to build up the foliage, creating a dense patchwork of colour and tone. Then use the white/cobalt blue mix to break a little sky into the foliage at the top of the painting. Switch to a no. 8 round bristle brush and use the same mix to build up the lighter tones on the stone wall.

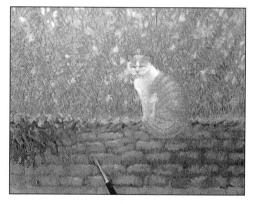

Develop the rough texture of the wall with short vertical strokes of thicker paint. Mix cadmium red and Prussian blue to make a dark grey for the shadows between the individual stone slabs, then add a little yellow ochre and white to the mixture to soften the tones. It's important not to let the wall dominate the painting too much – the focus should be on the cat and not on the background.

Work over the fur on the cat's face with cadmium yellow to introduce highlights. Paint the ears with a mix of cadmium red, burnt sienna and white, then outline them with a fine line of pure white to separate the cat from the background. Emphasize the striped markings with short strokes of cadmium yellow mixed with white. Add a little cadmium red and yellow ochre to the mixture and darken the orange fur on the back and tail with loose, scumbled strokes.

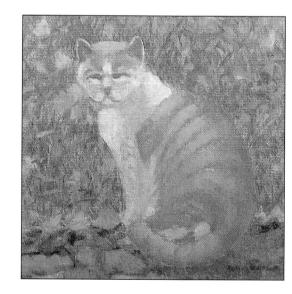

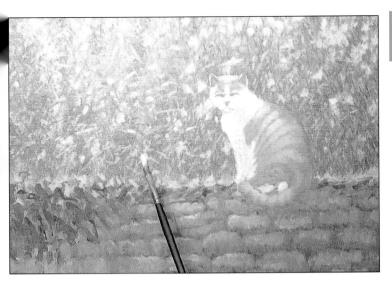

Helpful Hint
AT AROUND THIS POINT IT'S.
DO ALLOW THE PAINT TO DRY

AT AROUND THIS POINT IT'S A GOOD IDEA TO ALLOW THE PAINT TO DRY FOR 24 HOURS OR SO BEFORE CONTINUING. IT IS DIFFICULT TO APPLY THE FINISHING DETAILS ON TOP OF A WET PAINT SURFACE.

Use mixes of cadmium red and Prussian blue to add the deeper tones in the background foliage, then redefine the patches of sky with cobalt blue and white. Moving back to the cat, scumble some strokes of pure white over the fur on the neck and chest to give it a softer appearance. Put in the eves with a mixture of cadmium red and Prussian blue. Build up the mottled pattern on the stone wall with broken strokes, using varied mixes of vellow ochre, white and touches of cobalt blue.

To finish the picture, add warmer highlights on the wall with mixes of cerulean, cadmium red and white. Accentuate the highlights on the ivy, too, using cerulean, lemon yellow and white. Repeat some of this colour in the background foliage to provide colour balance. Finally, mix cadmium red and white and suggest some pinkish twigs in the background with random strokes.

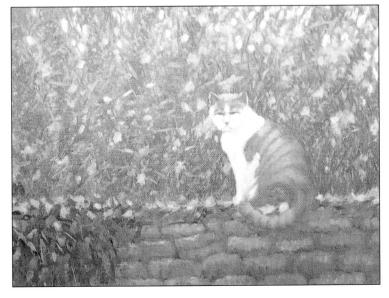

Painting Skies

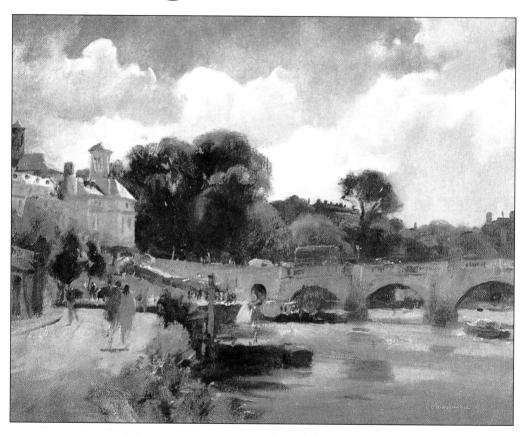

Trevor Chamberlain

SUMMER AT RICHMOND

Clouds directly in front of the sun are particularly exciting to paint because the backlighting makes them appear luminous and gives them a 'silver lining'.

The sky tends to set the mood of a landscape because it is the source of light. It is important, therefore to treat the sky as an integral part of the landscape and not merely as a backdrop. As you paint, try to bring the sky and the land along simultaneously, working from one to the other and bringing some of the sky colour into the land and vice versa.

Techniques

In order to suggest the airiness of the sky and clouds, it is best to work quickly and simplify what you see. Look for the main shapes and block them in with thin paint, then start to

introduce detail and modelling. By varying your brushwork and the consistency of the paint, you can create a range of subtle effects that suggest the amorphous nature of clouds and sky. Creamy, opaque colour will suggest groups of dense, advancing clouds; thinly applied, transparent colour gives the impression of atmosphere and receding space, and is ideal for portraying distant clouds and areas of dark, remote sky.

To achieve the effect of distant haze, blend wet colour into wet, taking some of the sky colour into the land and vice versa.

This slight softening of the horizon gives a marvellous sense of air and light.

Modelling clouds

Look carefully at cloud structure. Clouds are not flat shapes but have three-dimensional form, with distinct planes of light and shadow. Warm colours - reds, oranges and yellows - appear to come forward, as our eyes are more receptive to them. Cool colours - blues, greens and violets - appear to recede. Therefore the contrast of warm and cool colours can be used to model the advancing and receding planes of clouds. The lit areas of cumulus cloud, for example, may contain subtle hints of warm yellow and pink, depending on the weather and the time of day. Those parts of the cloud which are in shadow may appear grey or even brown in colour, and contain blues and violets.

Too many hard outlines make clouds appear 'pasted on' to the sky and destroy the illusion of form.

Partially blend the shadow edges of clouds into the surrounding sky so they blend naturally into the surrounding atmosphere.

John Denahy

SUFFOLK COAST

Instead of painting the sky as a flat area of blue, the artist has used broken strokes of vibrant blues, violets, greens and yellows, laid over a warm-toned ground. This gives a more vivid impression of the sparkle of a summer sky.

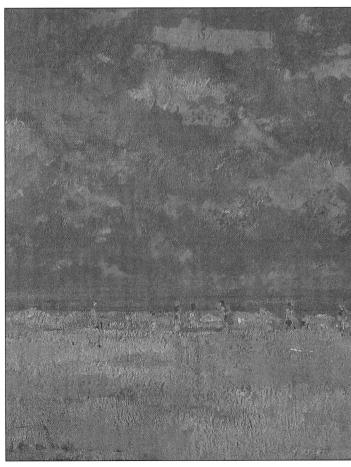

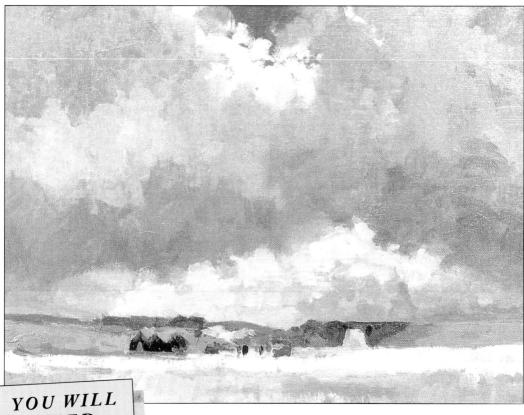

NEED

- Sheet of primed board, 12 x 10in (30.5 x 25.4cm)
- No. 3 round sable brush
- No. 4 flat bristle brush
- No. 5 round bristle brush
- V Painting knife
- Refined linseed oil
- V Distilled turpentine

Sky Over Suffolk

The sky need not be a mere backdrop to your landscape paintings - it can sometimes be a subject in its own right. In this painting the dramatic clouds form virtually the whole composition, with

OIL PAINTS IN THE FOLLOWING COLOURS

- Burnt sienna
- French ultramarine
- Lemon yellow
- Ivory black
- Titanium white
- Alizarin crimson
- Cadmium yellow
- Cadmium orange
- Raw umber Cerulean

the narrow strip of hills and fields serving as an anchor to the movement above.

Working on a board tinted with a thin wash of burnt sienna, use a no. 3 round sable brush and diluted burnt sienna to sketch in the details on the horizon. Start by establishing the broad tones in the sky and land using a no. 4 flat bristle brush. For the green fields, mix varying amounts of lemon yellow, French ultramarine, ivory black and titanium white. Rough in the sky using ultramarine, white and a touch of alizarin crimson, plus greys mixed from varied proportions of ultramarine, lemon yellow, black and white.

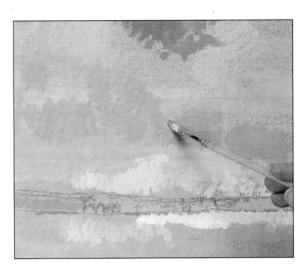

Helpful Hint

LEAVE PATCHES OF THE GROUND BARE IN THE EARLY STAGES SO THAT LATER ADDITIONS OF COLOUR CAN BE SLIPPED INTO THE GAPS. THIS AVOIDS THE DANGER OF OVERWORKING THE AREA WITH PAINT.

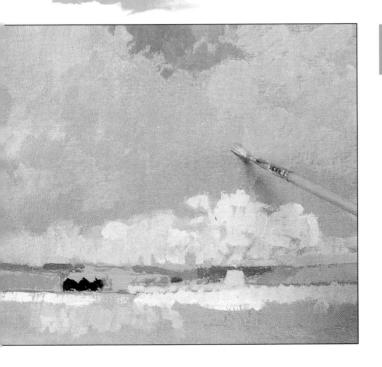

Suggest the land-scape features in the distance using some of the colours already on your palette. Continue building up the tones in the sky using the same colours mixed in step 1. By varying the proportions of colour used, it is possible to create a wide range of colourful greys ranging from greenish grey through to grey-violet.

OIL PAINTING

Work over all the areas of the painting at the same time, moving from the sky to the land and back again and constantly making adjustments to the relative tones and colours. Use a no. 5 round bristle brush to lay in the smaller clouds with rapid brushstrokes, letting some of the colours blend wet-into-wet at the edges.

Begin to use slightly thicker, creamier paint now, and build up the cloud masses with broad strokes, slurring the

colours wet-into-wet. Paint the sunlit white clouds with loose strokes of white, warmed with touches of cadmium orange and cadmium yellow. Now work on the large, light cloud on the horizon with a combination of ultramarine, alizarin, raw umber and plenty of white.

Helpful Hint

TAKE THE TIME TO
OBSERVE THE VARIOUS
CLOUD TYPES AND THEIR
CHARACTERISICS AND MAKE
SKETCHES OF THEM. THESE
SKETCHES WILL HELP YOU
PAINT SKIES MORE
CONVINCINGLY.

Mix a pale, cool grey from ultramarine, alizarin crimson and white and scumble this lightly over the brownish clouds near the top of the sky to give the effect of smaller clouds passing across the large mass of cumulus. Now begin to soften some of the edges of the clouds by blending very gently with a painting knife.

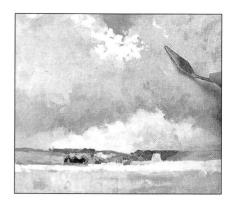

At this point it is often a good idea to take a short break from your painting so that you can return to it with a fresh eye and make any necessary corrections or modifications. Here, for example, the cloud mass on the left is a little too heavy, so mix cerulean and white and scumble over the dark grey area to lighten it. Then lighten the brownish area just above it with white, burnt sienna and lemon yellow.

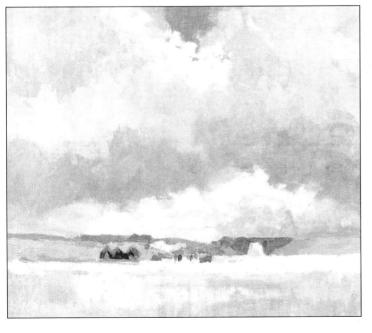

Work over the whole picture, modifying colours and softening edges where required; for example, soften the patch of white cloud at the top of the picture to integrate it into the patch of blue sky.

Index

acrylic paint 23, 52	Curtis, David	greens, mixing 30-1
Adams, Alastair	Fishing by the Lake 30	
Sheep 67	Hot August Evening, River	harmony of colour 80-1
alla prima 16	Idle 39	Horton, James
Autumn Trees 48-51	Sleet and Snow, Hathersage 47	Boys Bathing After a Storm 22
Autumn Trees by Ted Gould 46		Grantchester, Cambridge 23
	Denahy, John	Hot August Evening, River Idle by
blending 38-9	Shoreham Valley 74	David Curtis 39
boards 15	Suffolk Coast 89	
toned grounds 22-3	developing the painting 60-1	impasto 66-7
Boudoir, The 55-9	diluents 32-3	•
Boys Bathing After a Storm by	dipper 10, 15	knife painting 15, 74
James Horton 22	••	1 0
brushes, oil painting 11-12	equipment 10-11	landscapes
blending 39	Eric's Geese by Trevor	alla prima 16
bristle 11, 12	Chamberlain 16	blending 38-9
care 12		greens, mixing 30-1
decorators' 12	Fishing by the Lake by David	skies 88-9
filberts 11, 12	Curtis 30	trees 46-7
shapes 12		linseed oil 11
sizes 12	Galton, Jeremy	use in preparing wooden
synthetic 12	Roses in Blue Vase 38	palettes 13
	Garden in Spring 68	•
canvas 14-15	Garden in Spring by Ted Gould 66	mahl stick 11, 15
toned grounds 22-3	Gilbert, Dennis	Marmalade Cat 82-7
Cézanne, Paul 61	Green Still Life 80	materials 10-15
Chamberlain, Trevor	Red Still Life 52	mediums 11
Eric's Geese 16	Washing Line, Murano 61	
Summer at Richmond 88	Gould, Ted	paints, oil painting 10-11
Chania at Night 75	Autumn Trees 46	artists' 10
clouds 88-9	Garden in Spring 66	diluents 11
colour	graduations of tones and colours	grades 10
balancing 60-1	38-9	linseed oil 11
blending 38-9	Graham, Peter	mediums 11
greens, mixing 30-1	Le Petit Déjeuner 60	safety precautions 11
harmony 80-1	Grantchester, Cambridge by	thinner 11
toned grounds 22-3	James Horton 23	turpentine 11
wheel 81	Green Still Life by Dennis	white spirit 11
Country Scene, A 32-7	Gilbert 80	

palettes, oil painting 13 dipper 10, 15 knives 15 preparing wooden 13 thumbhole 13 Petit Déjeuner, Le by Peter Graham 60

Red Still Life by Dennis Gilbert 52 Roses in Blue Vase by Jeremy Galton 38 Rubens, Peter Paul 52

safety precautions with solvents 11

Sheep by Alastair Adams 67
Shoreham Valley by John Denahy
skies 88-9
Sky Over Suffolk 90-3
Sleet and Snow, Hathersage by
David Curtis 47
Spring Flowers 17-21
Still Life in Blue and White 40-5
Suffolk Coast by John Denahy 89
Summer at Richmond by Trevor
Chamberlain 88
supports 14-15

Terrace in Tuscany 62-5 thinners 11 toned grounds 22-3 trees 46-7 turpentine 11

underpainting 52

Venice, Evening 24-9

Washing Line, Murano by Dennis Gilbert 61 white spirit 11

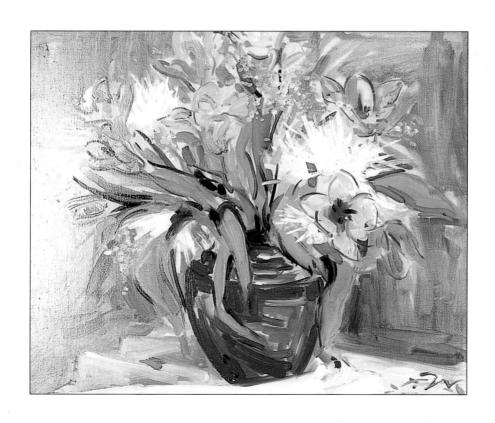

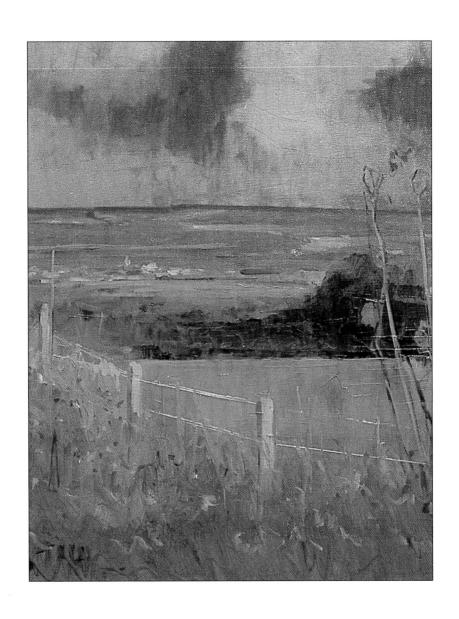